IMAGES
of America

BAY VIEW

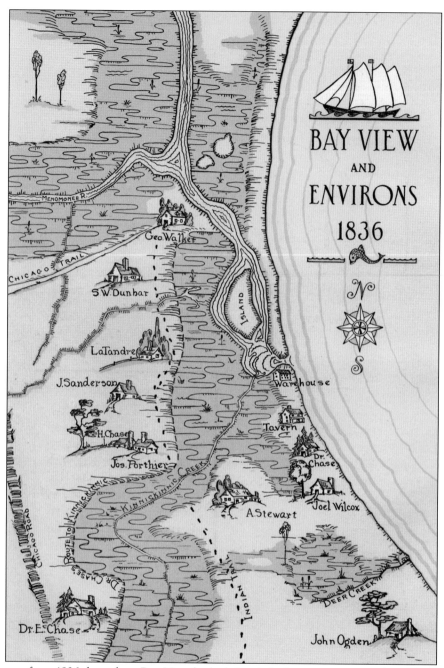

This map from 1836 shows how Bay View looked shortly before pioneers moved in. The Indian Trail at bottom center of this map eventually became South Kinnickinnic Avenue, which, along with South Howell Avenue, is one of the two north–south thoroughfares in Bay View.

ON THE COVER: These happy Bay Viewites were members of the 1937 Humboldt Park Fourth of July Association. Humboldt Park's Fourth of July celebration is the oldest in the city of Milwaukee. It was started in 1910, in response to the high rate of injuries from fireworks during unorganized celebrations. (Courtesy of the Bay View Historical Society.)

IMAGES
of America

BAY VIEW

Ron Winkler

ARCADIA
PUBLISHING

Published by Arcadia Publishing
Charleston, South Carolina

Printed in the United States of America

Library of Congress Control Number: 2011939259

For all general information, please contact Arcadia Publishing:
Telephone 843-853-2070
Fax 843-853-0044
E-mail sales@arcadiapublishing.com
For customer service and orders:
Toll-Free 1-888-313-2665

Visit us on the Internet at www.arcadiapublishing.com

*This book is dedicated to Bay Viewites past, present, and future,
whose sense of community pride and spirit is unique.*

CONTENTS

ACKNOWLEDGMENTS

Nothing exists in a vacuum, and this book is no exception. My initial interest in Milwaukee's history was sparked by a tour of the city in 2002, led by Milwaukee's top historian, John Gurda, whose *Making of Milwaukee* is the gold standard for a history book.

Shortly after that tour, I attended my first Bay View Historical Society meeting and joined a committee being formed to do research for a series of walking tours of Bay View. My enthusiasm for the project was so great that the committee let me direct it. My starting point was the brochure "Walking Tours of Bay View," which stated that the walks were "initiated and conducted by Ray Bethke and John Utzat in 1979 on the One Hundredth Anniversary of the founding of the Village of Bay View, Wisconsin." I used those six walks for my model and added three more. That research became the starting point for this book.

The bulk of my research was done at the Bay View Historical Society. I would like to thank the Bay View Historical Society's archives committee for their dedication and thoroughness in preserving Bay View's history. This book would have been impossible without the photographs and information in those files. The women of the committee are the late Lois (Lawrie) Rehberg, Nadine (Goldstein) Barthuli, Janis (Hansing) Liedtke, Sandy Schuetz, and Evelyn (Sather) Trisco.

I would like to thank the Bay View Historical Society's board of directors for their enthusiasm and support for this project.

Numerous individuals and institutions contributed photographs and information. Thanks to all of you.

Most of all, I wish to thank my wife, Alice, for her advice and support. Her love and understanding served as a road grader to smooth out the bumps and potholes along the road to completing this book.

Unless otherwise noted, all images appear courtesy of the Bay View Historical Society.

INTRODUCTION

In the early 1830s, the area that would become Bay View was mainly dense forest inhabited by Native Americans, who had been here for thousands of years. The Indians had a series of trails through this wilderness that they used for hunting. One of those trails evolved into Kinnickinnic Avenue. To the east near Lake Michigan, Deer Creek flowed northwest, roughly following what, today, is Delaware Avenue before emptying into Lake Michigan.

In the mid-1830s, the federal government started removing the Indians onto reservations west of the Mississippi River. Immediately, pioneers moved in to stake their claims to this wilderness. Many came from New York and New England via the Erie Canal, which had opened in 1825. Once they reached Detroit, they had two options. The most popular option was to sail across Lake Michigan. The second option was to travel by land around the south shore of Lake Michigan to Chicago. At that point, they were faced with two more choices, which were both government roads that passed through Milwaukee on their way to Fort Howard (present-day Green Bay). Green Bay Road was the official military highway, and remnants of this highway in Milwaukee are Whitnall Avenue and Green Bay Avenue. The second road was the previously mentioned Indian trail, which the military improved to form the Chicago Road (today's Kinnickinnic Avenue).

Whichever route they chose, water was part of the attraction, for there was great fishing in Lake Michigan and Milwaukee's three rivers. However, the main attraction was the potential for commercial growth at the best port on the western shore of Lake Michigan. The Milwaukee, Menomonee, and Kinnickinnic Rivers, whose confluence and subsequent outlet into Lake Michigan formed a sheltered harbor that offered protection from the lake's violent weather, made this possible.

These first settlers built log cabins along the banks of Lake Michigan and the rivers, which, in the Bay View area, were the Kinnickinnic River and Deer Creek. By 1837, the entire wilderness was occupied. There was no local government, so they formed the town of Lake in 1838. Because travel and communications were slow, subsequent inhabitants clustered in cities, and the town population of subsistence farmers remained small.

In 1855, the railroad linking Chicago with Milwaukee was completed, with a stop in Bay View near what today is Conway Street. This two-hour, 90-mile direct line between Chicago and Milwaukee eliminated the 200-mile, 24-hour train and stagecoach trip via Janesville.

Even so, the Bay View area remained woods and farmland until 1867, when Detroit entrepreneur Eber Brock Ward established the Milwaukee Iron Company next to Lake Michigan at the mouth of Deer Creek. Ward was drawn to this area because it was along rail and water marketing routes and was close to regional iron ore supplies.

Ward's Milwaukee Iron Company (also known as the Bay View Rolling Mill, North Chicago Rolling Mill, and United States Steel) was purposely established outside of Milwaukee in the town of Lake to avoid city taxes. However, its isolation, far from the population center of Milwaukee, required Ward to construct a company town and import skilled steel workers from Great Britain, where the Industrial Revolution was in full swing.

Ward laid out his company town immediately south of the steel mill between Deer Creek and Lake Michigan. He aligned his north–south streets parallel to the northwest–southeast trend of

both bodies of water. Therefore, the intersecting east–west streets actually run southwest–northeast. Ward also named the streets, some for steel mill employees (Potter, Clement, and Russell) or bodies of water (Superior, Ontario, St. Clair, and Deer).

Deer Creek, along with the railroad, which still parallels the Lake Parkway, formed a barrier, which resulted in an east Bay View and a west Bay View. Ward's company town in east Bay View was populated by immigrants from Great Britain while west Bay View, across the railroad tracks, had a high percentage of Germans.

As the steel mill grew, additional housing was needed to accommodate workers and their families. Landowners responded with hastily platted subdivisions, lacking uniformity in lot size and block length. In addition, street names frequently changed at each jog in the road or when they were extended into a new subdivision.

In west Bay View, Joseph Williams owned land on both sides of Kinnickinnic Avenue from Potter Avenue to just south of Lincoln Avenue. When he subdivided his property west of Kinnickinnic Avenue in 1870, he platted the streets in the standard north–south grid. However, on the east side of Kinnickinnic Avenue, he angled his streets to align with Ward's northwest–southeast pattern in the company town.

Williams named one street for himself, but it is not known who or what he and his family had in mind when they named the following streets: Conway, Dover, Homer, Lenox, Linus, and Woodward. However, Sanford Williams was Joseph Williams's son, and his attorney was Graham Wilson. Sanford named Graham Street and his mother, Catherine, named Wilson Street. Interestingly, the two streets intersect. Otjen Street was named for Christian and Theobald Otjen, who were orphans under the care of Eber Brock Ward's sister before they came to work at the Milwaukee Iron Company.

Over the years, the merger of Bay View's village street pattern, the city of Milwaukee's standard north–south grid system, and the old diagonal pioneer roads such as Kinnickinnic Avenue and Chase Avenue formed numerous multipoint intersections. Traffic patterns in these areas can be quite challenging today.

The Milwaukee Iron Company donated land for many of Bay View's churches, including Immaculate Conception Catholic Church, St. Lucas Lutheran, St. Luke's Episcopal, Trinity Methodist, United Brethren, United Church of Christ, and Bay View Baptist. Welsh immigrants built the oldest surviving church in Bay View in 1873. Today, the church at 2739 South Superior Street is home to the Christian Science Society, which took over in 1957 and rebuilt the front part of the building by adding a Doric-style front porch.

The "little red schoolhouse" was built in 1873 at what today is 2523–2541 South Wentworth Avenue. The schoolhouse cost $11,000 and opened on September 8, 1873. It contained the primary grades through two years of high school. The brick Italianate building was razed around 1901, and the vacant lot was used as a playground known as the Beulah Brinton playground until 1954, when four residences were built on it.

One of Bay View's most famous landmarks is the iron well in the 1700 block of East Pryor Avenue. It is the only artesian well left in Milwaukee, and people come from all over the city to fill jugs with fresh spring water. The well was drilled in 1882–1883 to provide fire protection for the "little red schoolhouse" located nearby. Today, a pump brings water to the surface and the Health Department monitors the water quality several times a year. The well was designated as a historic structure by the City of Milwaukee in 1987.

Neither the Town of Lake government nor the steel mill could provide adequately for the company town. Therefore, Bay View incorporated in 1879 with 892 acres (almost one square mile) and a population of 2,592. However, the inadequate village funds were unable to provide streetlights, sewers and other essential services. Therefore, in 1887, the residents of Bay View voted to join the city of Milwaukee to obtain these and other services.

When the Milwaukee Iron Company was founded in 1867, it opened the door to industrialization and paved the way for Milwaukee to become the "machine shop of the world." Ward's company town was Milwaukee's first industrial suburb and Wisconsin's first company town. The steel mill

remained Bay View's largest employer until the early 20th century. It was shut down in 1929 and razed in 1939.

Today, a State of Wisconsin Historical Society marker on the northeast corner of Superior Street and Russell Avenue is the only reminder of the steel mill that once extended north from there along the lakefront onto Jones Island. The marker also commemorates the Bay View Tragedy, the most dramatic event in Bay View's history. On May 5, 1886, strikers marched toward the steel mill as part of a nationwide call for an eight-hour workday. Seven people were killed when the Wisconsin state militia fired on the marchers.

In 1982, a portion of Bay View was designated as a National Historic District. The boundaries are roughly Conway Street on the north, Lake Michigan on the east, Meredith Street on the south, and the Lake Parkway on the west. In addition, numerous buildings in Bay View are on the National Historical Register.

Most people credit the naming of Bay View to Mrs. William Durfee, wife of the chief engineer of the steel mill and daughter of Joseph Williams.

Although Bay View became part of Milwaukee in 1887, it continued as a self-sufficient community whose independence was born out of isolation. This sense of community in Bay View was so strong that, even after the village joined the city of Milwaukee, the Bay View name was preserved. In addition, the Bay View name extended into the city of Milwaukee north of the old village boundary and later to the adjacent town of Lake to the south and west that subsequently became part of the city of Milwaukee.

Today, there is a Bay View High School, library, and post office, as well as many businesses that have attached Bay View to their names. Even the media refers to Bay View by name when reporting events, so it is no surprise that many people believe that Bay View still is a Milwaukee suburb. Today, the boundaries of Bay View are roughly Becher Street/Bay Street on the north, Sixth Street on the west, Morgan Avenue on the south, and Lake Michigan on the east.

Bay View's self-sufficiency that was born out of isolation has been a double-edged sword. The geographic isolation continued into the 20th century, and attempts were made—some by Bay View's Alderman Erwin Zillman—to construct a bridge that would extend North Lincoln Memorial Drive south over the harbor to Bay View. Finally, in 1977, with the opening of the Hoan Bridge, Bay View had a direct link to downtown Milwaukee. However, many Bay Viewites were nonplussed when the Hoan Bridge was nicknamed the "bridge to nowhere." Eventually, the tide turned when Milwaukee, via the "bridge to nowhere," discovered the city's "other east side," as Bay View became known for a time shortly thereafter. In addition, South Shore commuters from Cudahy, St. Francis, Oak Creek, and South Milwaukee discovered Bay View as they drove through the community on their way to the Hoan Bridge and downtown. As a result, the quiet residential community of Bay View is experiencing a renaissance by the merchants and citizens of Milwaukee.

The Bay View Historical Society, established in 1979, is dedicated to maintaining the Bay View community through conserving, celebrating and sharing Bay View's rich heritage. The society also designates landmarks throughout Bay View and publishes a newsletter, *The Historian*, which contains articles of local historical interest. During the year, the society conducts general membership meetings, historic walks, and other social events.

In 1986 and 2011, the Wisconsin State Historical Society awarded the Bay View Historical Society its highest award of excellence, the Reuben Gold Thwaites trophy.

Membership in the society is open to anyone interested in supporting its programs:

Bay View Historical Society
2590 South Superior Street
Milwaukee, WI 53207
www.bayviewhistoricalsociety.org

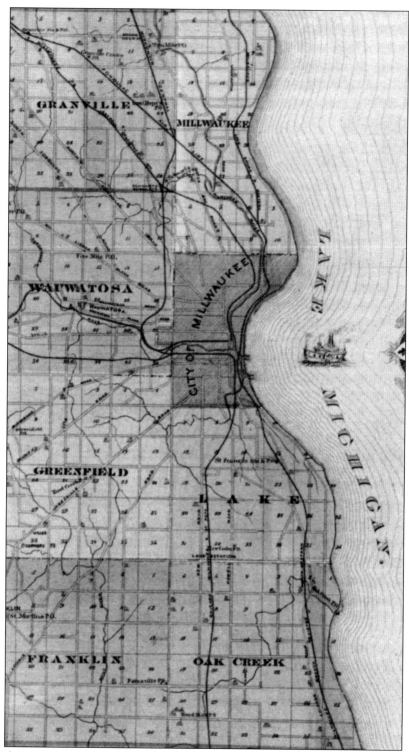

Here are the seven townships of Milwaukee County in relation to the city of Milwaukee in 1876. The future Bay View would occupy the northeast part of Lake Township.

One

EARLY PIONEERS

Wisconsin was originally part of the Northwest Territory, which was formed after the American Revolution. Five states were eventually carved from this territory—Illinois (1818), Indiana (1818), Ohio (1803), Michigan (1837), and Wisconsin (1848). By 1834, Wisconsin was part of Michigan Territory and was divided into two counties, Brown and Crawford. In that year, the southern portion of Brown County became Milwaukee County. In 1836, Milwaukee County was greatly reduced to what today are Milwaukee and Waukesha Counties.

When the city of Milwaukee was founded in January 1846, residents of western Milwaukee County responded by forming Waukesha County to distance themselves from Milwaukee County's increasing urbanization.

In 1838, Milwaukee County itself was divided into the townships of Milwaukee and Lake. During the next three years, these two townships were subdivided to form eight townships whose rural government was suited for a combination of farms and wilderness. Bay View was part of Lake Township.

The original inhabitants of southeastern Wisconsin were Menomonee and Potawatomi Indians. They hunted in the lush forests and fished along the shores of Deer Creek, the Kinnickinnic River, and Lake Michigan. French, English, and American fur traders saw the potential value of this land, but it was the US government that worked to obtain this land from the Indians. The Indians ceded the land in 1833 but were given until 1836 to move west of the Mississippi River. However, pioneer influx began in 1834, before the US government officially opened the area to settlement. By 1837, all of the land was occupied by settlers who staked claims and built log cabins along the banks of the Kinnickinnic River, Deer Creek (which flowed along what today is Delaware Avenue), and Lake Michigan.

Many were Yankees from New York and New England who traveled first by boat via the Erie Canal and Lake Erie. They could then cross Lake Michigan or travel by land around the southern tip of Lake Michigan through Fort Dearborn (later Chicago) and then north on either the Green Bay Road or the Chicago Road. These first settlers were subsistence farmers.

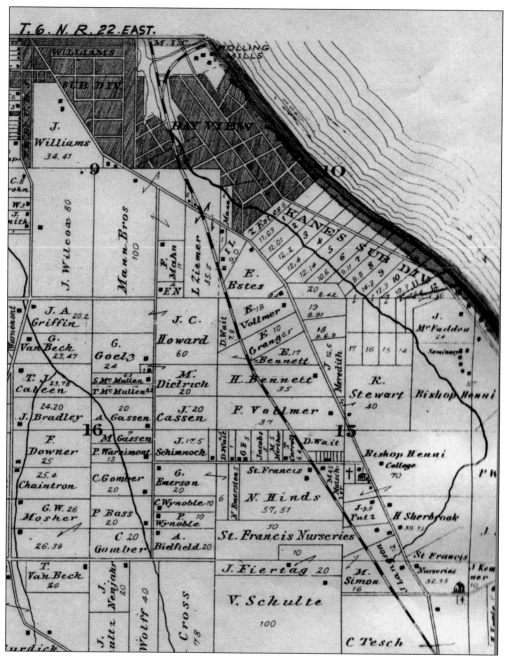

Many of the names mentioned in this book can be found on this 1876 map of Lake Township. At that time, the town's boundaries were what today is Lincoln Avenue (north), College Avenue (south), Twenty-seventh Street (west), and Lake Michigan (east).

According to historian Bernhard Korn, in 1834, Horace Chase, Samuel Brown, and Morgan L. Burdick founded what would eventually become Bay View. Chase (1810–1886) started a business selling meat, produce and whiskey on Lake Michigan at the harbor mouth, which at that time, was in Bay View, south of the current harbor, which was constructed in 1857. Chase was a member of Wisconsin's first state assembly in 1848, Milwaukee alderman in 1861, mayor of Milwaukee in 1862, and then alderman again in 1873, 1874, and 1879.

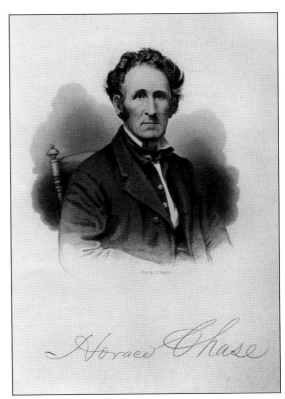

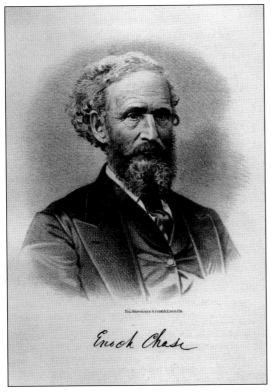

Chase's brother Dr. Enoch Chase (1809–1892) came to Milwaukee in 1835. The Chase brothers were natives of Derby, Vermont. Enoch graduated from Dartmouth College as a doctor, but switched to farming when he arrived in Milwaukee. Enoch served four terms in the Wisconsin State Assembly (1849–1851, 1853, and 1870) and as a senator from 1882 to 1884.

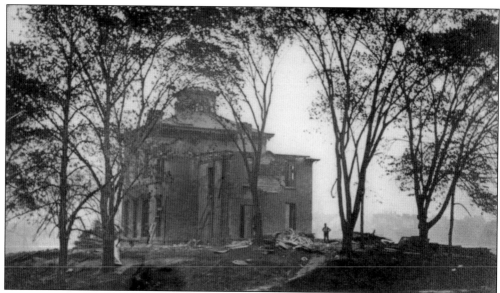

Enoch Chase owned land that stretched from Howell Avenue to Sixth Street and from Lincoln Avenue to Oklahoma Avenue. He platted his land and laid out the streets, naming two of them for his sons Clarence and Clifford and one for his son-in-law Samuel Burrell. Chase established a farm and built this home around 1847. Above is the house being razed in 1922 for the development of Baran Park, originally known as Chase Park. The Kinnickinnic River ran through Chase's farm, and Chase Avenue was originally constructed as a wagon road leading to the Kinnickinnic River. In 1876, along with his two sons, Chase opened the Chase Brickyards south of Lincoln Avenue on the east bank of the Kinnickinnic River. Ships docked along the riverbank when they brought wood for the kilns. In March 1880, Chase founded the Chase Valley Glass Company near his brickyards to supply bottles to Milwaukee's breweries. The business, shown below, went through several owners and name changes before being dissolved during Prohibition in 1921. (Courtesy the Milwaukee County Historical Society.)

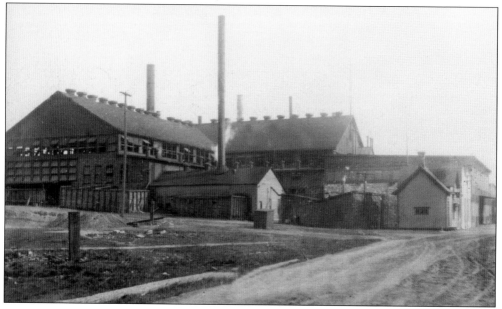

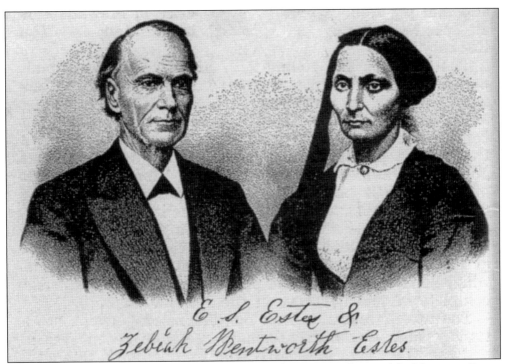

E. S. Estes & Zebiah Wentworth Estes

After the Black Hawk War in 1832, Native Americans were moved west of the Mississippi River. Settlers came to Bay View in 1836, attracted by fertile land and the harbor. Elijah Estes (1814–1887) was one of the first settlers in the area that today is known as Bay View. He came from North Carolina and, while passing through Chicago, met Zebiah Wentworth, his future wife. The couple built a log cabin on the shore of Lake Michigan on land that today is part of South Shore Park.

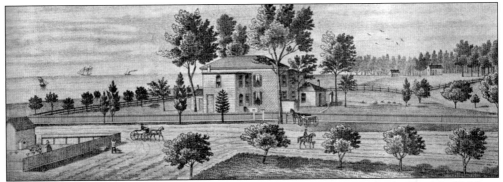

Shortly after Estes arrived in 1835, he purchased a quarter section (160 acres) of land for $1.25 per acre. The area was heavily wooded, but settlers were required to build a home and develop the land, which in those days, meant clearing it of trees and establishing a farm. This sketch from the 1876 *Milwaukee County Atlas* shows the Estes farm on the shore of Lake Michigan.

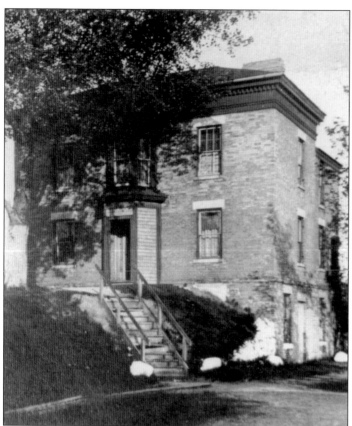

Estes built this home overlooking Lake Michigan in the 1850s. It is the same home depicted in the 1876 sketch on page 15. The home was razed in 1922, during development of South Shore Park.

Elijah Estes built this Victorian Italianate home in 1881 for his oldest son, Ren. The home, located at 2136 East Estes Street, is known as the Estes House and was designated as a landmark by the Bay View Historical Society in 1989. The Estes family named Estes Street and Wentworth Avenue in Bay View.

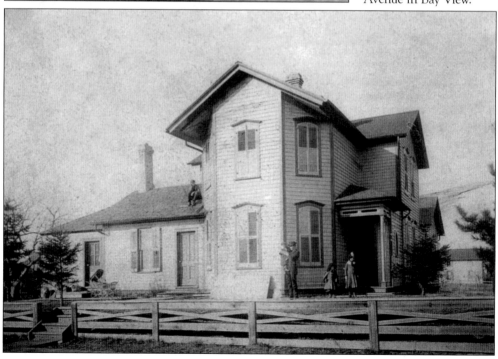

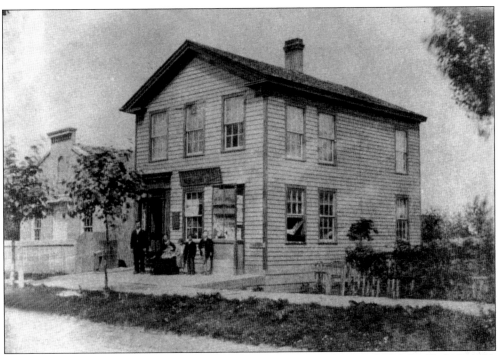

Joseph Bearman came from Baden, Germany, in 1850 and settled in Dunkirk, New York. In 1855, he relocated to Milwaukee, where he worked for various companies before opening this tailor shop on Kinnickinnic Avenue in the 1870s. (Courtesy of the Milwaukee County Historical Society.)

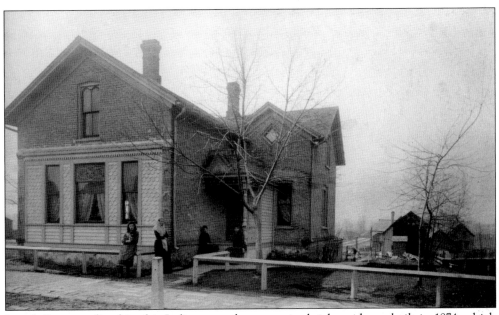

Joseph Bearman lived in this Italianate-style cream city brick residence built in 1874, which still stands at 2593 South Wentworth Avenue. The home's exterior has changed little since this late-19th-century photograph was taken. (Courtesy of tMilwaukee County Historical Society.)

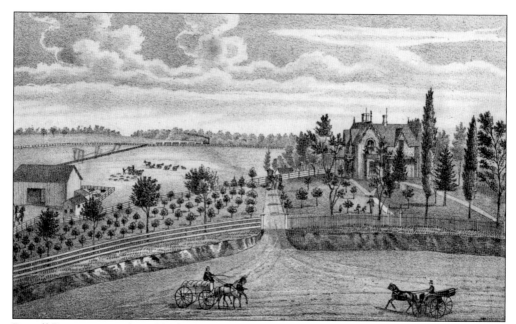

Russell Bennett arrived in 1836 from New Jersey. He purchased 160 acres of land and established a farm with his wife, Clarissa, and their six children. In 1855, he built a Gothic Revival–style home, shown in this sketch from the 1876 *Milwaukee County Atlas*, on the highest point of his land using cream city bricks obtained from the St. Francis Seminary brickyard just to the east. The seminary is still there, but the brickyard is gone.

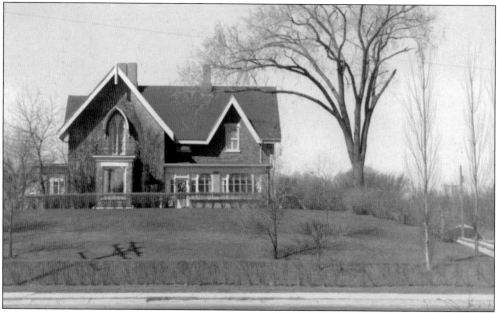

The Bennett House, seen in this 1959 photograph, still stands at 3317 South Kinnickinnic Avenue, and the current owners, consulting old photographs, are restoring the exterior of the home to its former elegance by replacing the fancy ornamentation on the gables, windows, and porches. It is the oldest known home in Bay View. Bay View's Bennett Avenue was named for Russell Bennett in 1929.

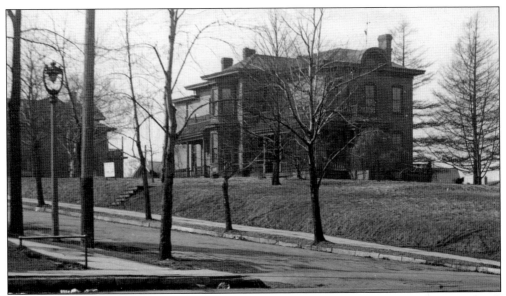

Joseph Williams (1795–1877) came from New York in 1836 and purchased 160 acres of land; its boundaries were present-day Lincoln Avenue, Russell Avenue, Williams Street, and Howell Avenue. Williams farmed the land and built this Italianate house in 1865 on the highest point of his land. When he subdivided his land, he named Williams Street for himself. The Bay View Historical Society designated the Williams home a landmark in 2011.

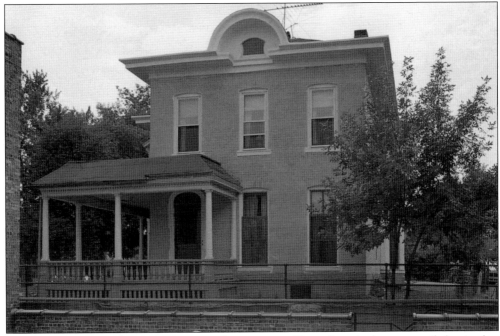

The Joseph Williams home faces east and was open to Kinnickinnic Avenue until the Avalon Theater complex was constructed in 1926–1929. The Ricketson family (Williams's daughter and son-in-law) sold the land for the theater to within two feet of the front porch. Therefore, the best view of the front of the home today is this one, from the roof of the Avalon Theater. (Courtesy of the City of Milwaukee Historic Preservation, Office of City Clerk.)

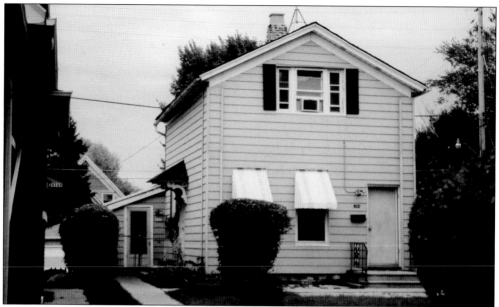

Uriel B. Smith (1812–1902) and his wife, Harriet, came to Milwaukee in 1835 from New York. They were the parents of Milwaukee's first white baby, Milwaukee Smith. Uriel was Milwaukee's first tailor and also owned a real estate business. In 1868, he purchased land from Joseph Williams and built this brick Italianate home on one of those lots. The house at 2418 South Howell Avenue is now covered with aluminum siding. Smith Street in Bay View was named for him. (Courtesy of the author.)

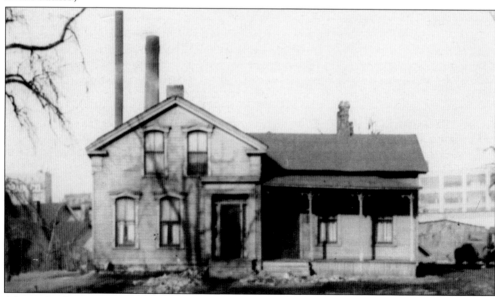

Alexander Stewart (1799–1873) came from Scotland. He and his wife, Elizabeth, established a 160-acre farm along Kinnickinnic Avenue between the Kinnickinic River and Lincoln Avenue. He donated land for a cemetery that was once located at the northeast corner of Kinnickinnic and Lincoln. Stewart built this home in 1839 on the northeast corner of Kinnickinnic Avenue and East Bay Street. The house, razed during the 1950s, was addressed at 2030 South Kinnickinnic Avenue. Stewart Street, one block north of this site, was named for him in 1879.

Two

THE STEEL MILL

In 1867, Eber Brock Ward selected the mouth of Deer Creek to establish the Milwaukee Iron Company. He was drawn to this area because it was along rail and water marketing routes, and it was close to regional iron ore supplies.

At the time, railroad tracks were made of iron. The iron tracks warped after a few years and had to be sent to rolling mills to be straightened (rerolled). In 1867, steel was replacing iron, and Great Britain was the only source of skilled steel workers. Therefore, Ward established Bay View as the company town for his steel mill (also known as the Bay View Rolling Mill, North Chicago Rolling Mill and United States Steel) and imported his work force from the British Isles.

Ward laid out and named the streets with names associated with water (Deer, Superior, Ontario, and St. Claire) or steel mill employees (Potter, Russell, and Clement). Ward not only built homes, but also sold land to those wishing to build their own homes. He also donated land for churches. Bay View was Wisconsin's first company town and Milwaukee's first industrial suburb.

The steel mill was Bay View's largest industry with about 2,000 employees at its height. Plans to expand further north onto Jones Island ended when the City of Milwaukee announced its own plans to construct a sewage treatment plant and the port of Milwaukee. Work at the Bay View mill was phased out as the company expanded its Gary, Indiana facility. Ageing equipment was not maintained, and in 1929, the company closed its doors.

It is interesting to imagine how Milwaukee's lakefront would look today if the company had expanded during the early 20th century. At any rate, Bay View owes its existence to Eber Brock Ward; Ward Street in Bay View was named for him. Bay View was Milwaukee's first industrial suburb and Wisconsin's first company town. The Milwaukee Iron Company paved the way for other industries in Milwaukee, such as Allis-Chalmers, Nordberg, and Harnischfeger, which earned Milwaukee the reputation as the "machine shop of the world."

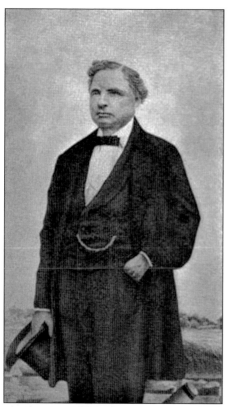

The Bay View area remained woods and farmland until 1867 when Detroit entrepreneur Eber Brock Ward selected the mouth of Deer Creek to establish the Milwaukee Iron Company. Ward's steel mill, also known as the Bay View Rolling Mill, North Chicago Rolling Mill, and United States Steel, was purposely established outside of Milwaukee in the town of Lake to avoid city taxes. However, its isolated location, far from the population center of Milwaukee, required construction of a company town. The town was then populated by a work force of skilled steel workers that Ward obtained from Great Britain, where the Industrial Revolution was in full swing. In the sketch below from 1879, the view is to the west from Lake Michigan. The steel mill is clearly visible in the foreground along the shoreline of Lake Michigan. The body of water in the center of the sketch is Deer Creek Pond. The road that stretches across the entire sketch and seems to form a boundary between the developed area and the wilderness is Kinnickinnic Avenue.

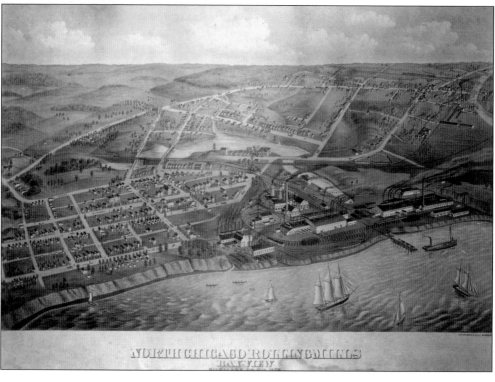

NORTH CHICAGO ROLLING MILLS
BAY VIEW

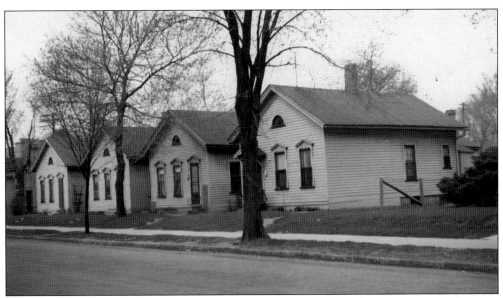

Ward laid out and named the streets in his company town. Some of the names referred to steel mill employees (Potter, Clement, and Russell) or water (Superior, Ontario, and St. Claire) and survive today. He built modest one-story frame Italianate puddler's cottages. Puddlers were the highly skilled workers who manufactured steel. The rows and rows of puddler's cottages throughout Bay View have disappeared, such as these four cottages (above) in the 1000 block of East Russell Avenue that were demolished in 1973 to build Michelle Manor, a senior living complex. A well-preserved row of three puddler's cottages still exists at 2725, 2731, and 2735 South Superior Street. Mill workers had the option of purchasing land and constructing their own homes. George W. Edmunds was a foreman at the steel mill who built the home below at 2550 South Shore Drive in 1873. It is one of the more elaborate puddler's cottages with delicate scroll saw brackets on the porch.

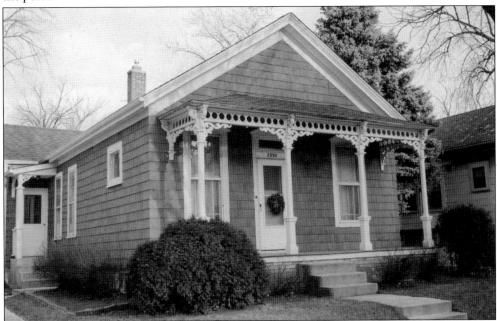

The George Starkey home was built in 1872 at 2582 South Shore Drive as a puddler's cottage. Architects Ferry & Clas remodeled it in 1897. Note the Classical Revival–style fluted porch columns. At that time, a library and solarium were added. George Starkey was born in England and moved to Bay View when his brother Joseph took over as superintendent of the Milwaukee Iron Company blast furnaces.

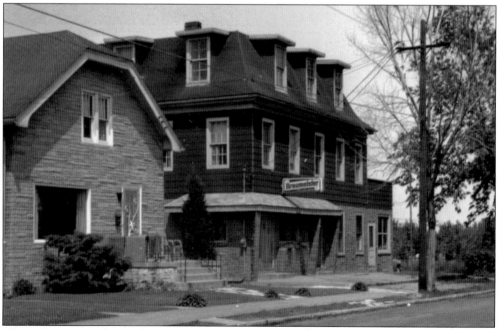

The Palmer House was built in 1868 at 2425–2427 South St. Claire Street. It has a mansard roof, which is rare in Bay View. The Palmer House was a hostelry with a capacity for 60 men. This largest of Bay View's boardinghouses is listed on the National Register of Historic Places.

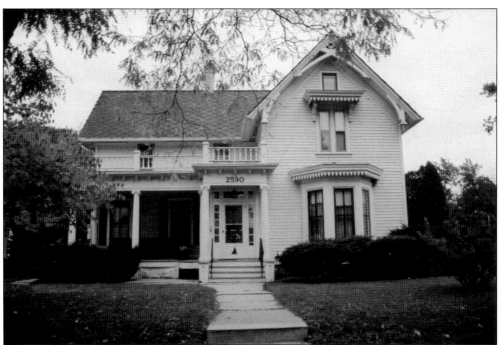

Millworker Warren Brinton built the Victorian Gothic Beulah Brinton home at 2590 South Superior Street in 1873. The Bay View Historical Society designated the Brinton home as its first historic landmark in 1983, and it became the society's headquarters in 2005. Warren's wife, Beulah, offered music and games and established Bay View's first library of 300 books in her home. In its 2011 booklet *100 Years of Recreation*, Milwaukee Public Schools credits Beulah Brinton with inspiring Milwaukee's social centers: "In the 1870s, Beulah Brinton's house at 2590 South Superior Street was a community gathering place for new immigrants in Bay View. For several decades, Mrs. Brinton provided recreation programs, enrichment classes, and even some basic medical care for her visitors. The Brinton House was a model for the social centers that Milwaukee Recreation would later open in the 1910s. In 1924, we opened our twelfth social center and named it after the woman who inspired the first eleven." That 12th social center is located at 2555 South Bay Street in Bay View. (Courtesy of the Milwaukee County Historical Society.)

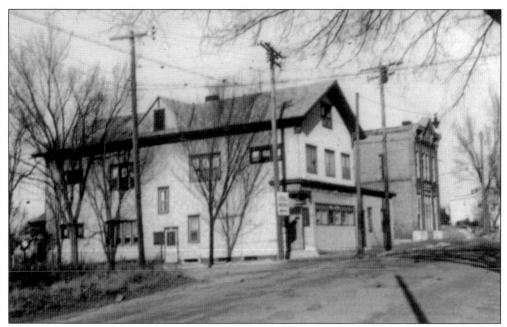

Puddler's Hall at 2461–2463 South St. Clair Street is the old union hall that was erected in 1873 with assistance from the Milwaukee Iron Company. In the early days, it was Bay View's only gathering spot for lectures, debates, plays, and concerts. Today, it is a tavern and residences that became a Bay View Historical Society landmark in 1986 and is listed on the National Register of Historic Places.

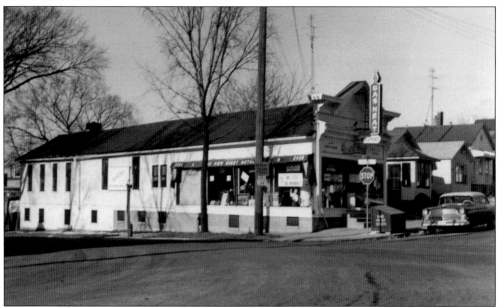

Lenck's Hardware Store at 2499 South Delaware Avenue was built around 1870 by the steel mill and remained in business until 1940. It was a gathering spot for news and gossip and also served as the village hall. It was subsequently Bay View Sheet Metal, as seen in this photograph from around 1960. Today, it is the Delaware House and has been a Bay View Historical Society landmark since 2009.

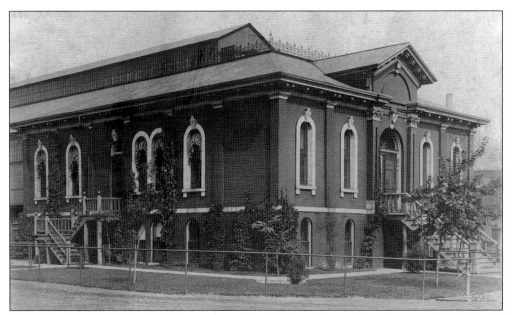

The Milwaukee Iron Company office was located at 1100 East Conway Street, just east of the Chicago Northwestern Railroad tracks and today's Lake Parkway. (Courtesy of the Port of Milwaukee.)

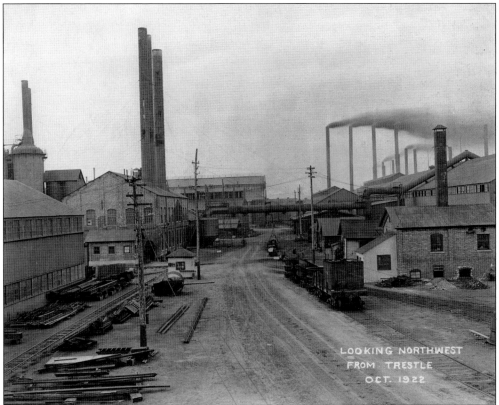

LOOKING NORTHWEST FROM TRESTLE OCT. 1922

This October 1922 view from inside the steel mill looks to the northwest. (Courtesy of Port of Milwaukee.)

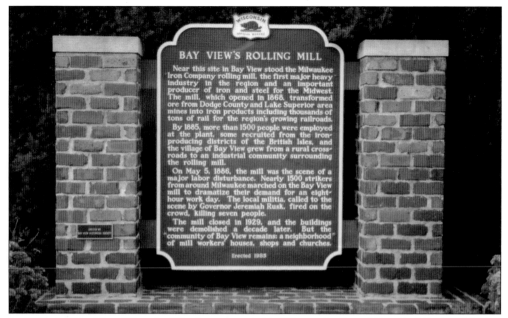

BAY VIEW'S ROLLING MILL

Near this site in Bay View stood the Milwaukee Iron Company rolling mill, the first major heavy industry in the region and an important producer of iron and steel for the Midwest. The mill, which opened in 1868, transformed ore from Dodge County and Lake Superior area mines into iron products including thousands of tons of rail for the region's growing railroads.

By 1885, more than 1500 people were employed at the plant, some recruited from the iron-producing districts of the British Isles, and the village of Bay View grew from a rural crossroads to an industrial community surrounding the rolling mill.

On May 5, 1886, the mill was the scene of a major labor disturbance. Nearly 1500 strikers from around Milwaukee marched on the Bay View mill to dramatize their demand for an eight-hour work day. The local militia, called to the scene by Governor Jeremiah Rusk, fired on the crowd, killing seven people.

The mill closed in 1929, and the buildings were demolished a decade later. But the community of Bay View remains: a neighborhood of mill workers' houses, shops and churches.

Erected 1985

In 1985, the Bay View Historical Society erected this Wisconsin State Historical Society Marker on the northeast corner of Superior and Russell at what was the southern boundary of the Milwaukee Iron Company. The marker, which is the only visible evidence of the steel mill, is also a memorial to the Bay View Tragedy of May 5, 1886. Strikers were marching to the Bay View Rolling Mill intent on shutting it down as part of the nationwide movement in support of an eight-hour workday. Seven people were killed when the Wisconsin State Militia, called in by Gov. Jeremiah Rusk, fired on the crowd. The photograph below of the militia was taken inside the steel mill.

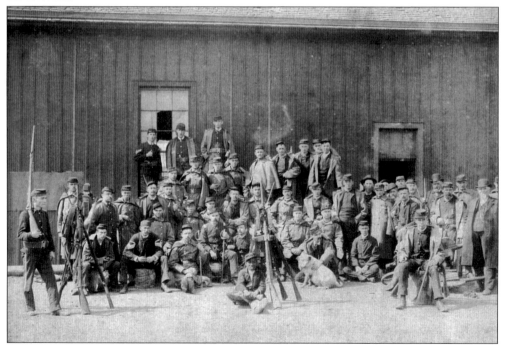

The Wisconsin Labor History Society and the Bay View Historical Society sponsor an annual commemoration of the Bay View Tragedy on the first Sunday in May. It is ironic that one of Bay View's streets is named for Wisconsin governor Jeremiah Rusk, who showed no remorse for the loss of life in Bay View when he remarked, "I seen my job and I done it."

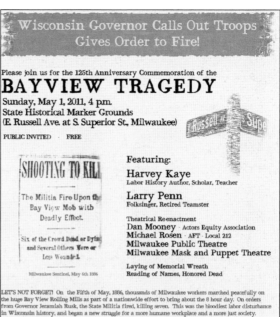

At its peak, the steel mill employed close to 2,000 men. It closed in 1929 and sat vacant, as seen here, until it was purchased by the City of Milwaukee in 1938 and torn down in 1939.

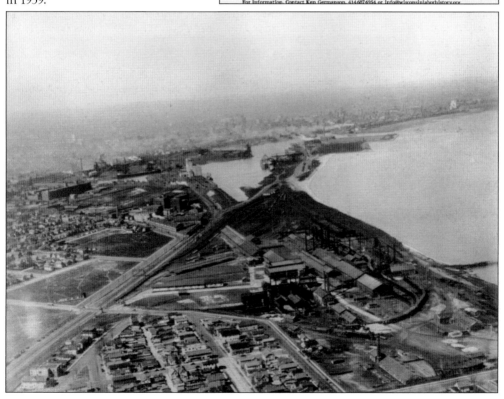

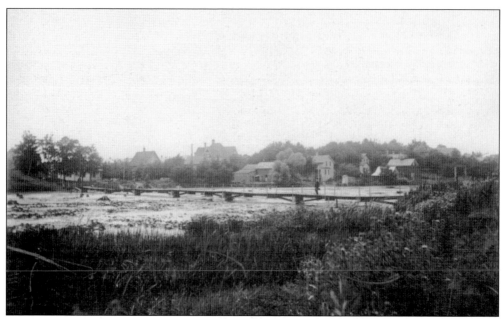

Deer Creek flowed north along what today is Delaware Avenue before flowing west under the railroad tracks at today's Russell Avenue. It then widened into a pond, which extended north to Lincoln Avenue before flowing east into Lake Michigan. This undated photograph shows the wooden footbridge constructed across Deer Creek Pond as the first attempt to connect east and west Bay View. The creek and pond were filled in during the late 19th century.

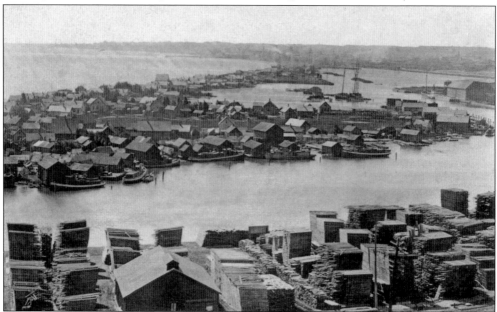

The steel mill was constructed partly on Jones Island, which was named for James Jones, who built a shipyard on the island in 1854. Jones Island was populated by squatters known as Kashubes, who were Poles from Kaszubky Province of West Prussia and Germans from the Stettin area of Pomerania. All were evicted when Milwaukee chose Jones Island as the site for its sewage treatment plant.

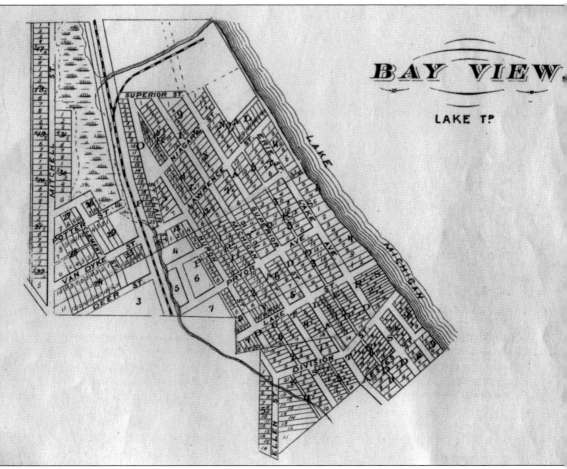

Neither the Town of Lake government nor the steel mill could provide adequately for the company town so Bay View incorporated as a village in 1879. However, village funds were inadequate to provide streetlights, sewers and other essential services that city of Milwaukee residents had. In 1887, the residents of Bay View voted to be annexed by the City of Milwaukee. Eber Brock Ward was an advocate of temperance and banned the sale, consumption, or distilling of alcohol on any company property. That ban extended to homes in the company town, whether they were leased or sold. The other landowners followed Ward's example, making Bay View a dry community. In fact, in the event of a violation, the property would revert back to the original owner. When Milwaukee's city limits reached Bay View's northern boundary at Lincoln Avenue, many saloons were opened on the Milwaukee side. Bay Viewites then had easy access to alcohol, and village fathers noted the revenue flowing across the border into Milwaukee. Debate continued for years among politicians and citizens alike.

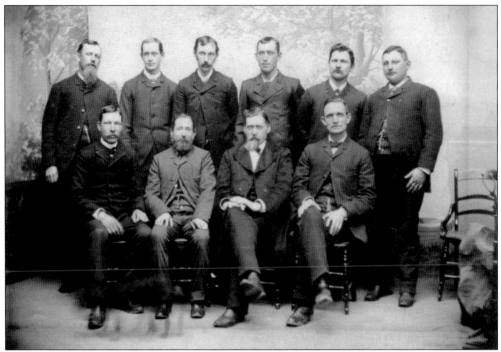

This is the Bay View Village Board in 1886. From left to right are (first row) Theobald Otjen, Allen Hutchison, Francis Seely, and Jacob Bullock; (second row) William Donahoe, Peter Bauer, Gustav Steffens, William Okershauser, Frank X. Ulrich, and Frank Webber. (Courtesy of Milwaukee County Historical Society.)

The Bay View Village Hall was originally constructed on the triangle bounded by Kinnickinnic Avenue, Clement Avenue and Pryor Avenue. Bay View builder Anton Stollenwerk completed the hall in January 1886. Around 1900, the hall (center) was moved to this location on the southeast corner of Logan Avenue and Russell Avenue. The hall was razed in 1939. At right is the old Bay View Baptist Church.

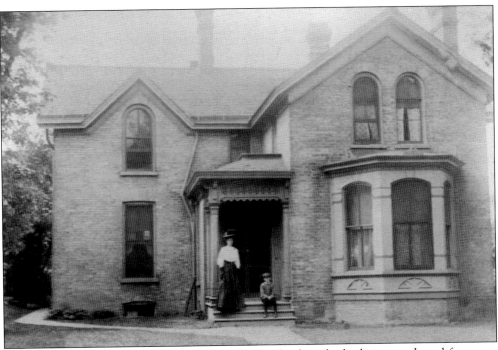

John T. Meredith (1840–1911) was born in England, where he built iron and steel furnaces. He came to the United States in 1868 and built furnaces for Eber Brock Ward in Chicago and Milwaukee. For a time, he was Bay View's village president. Meredith's home, built prior to 1888 at 607 East Lincoln Avenue, is pictured before it was remodeled to Dutch Colonial Revival. (Courtesy of Audrey Focault.)

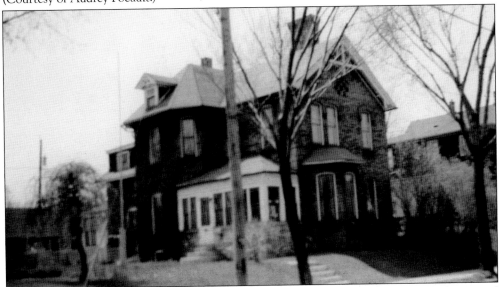

John, Richard, and George Meredith founded Meredith Brothers Company in 1892 as general contractors. Their office still stands at 2363 South Kinnickinnic Avenue. Another brother, William, was a mason who came from England and worked at the Milwaukee Iron Company. William's Italianate cream city brick home, built around 1871, is located at 719 East Lincoln Avenue. Meredith Street was named for the family in 1900.

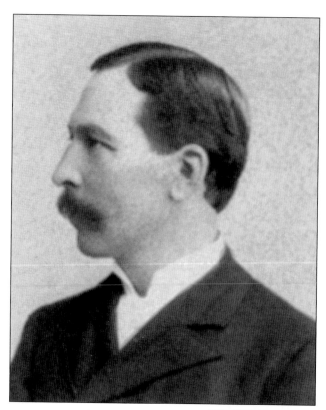

Theobald Otjen (1851–1924), pictured above, and his brother Christian, pictured below, were orphans from Michigan who were under the care of Eber Brock Ward's sister. Ward brought them to Milwaukee in 1870 to work in the rolling mill. Theobald became Bay View's village attorney, and Christian was village treasurer. Theobald continued his political career, serving as Bay View's alderman from 1887 to 1894, and serving in Congress from 1894 until 1906. The brothers founded the law firm of Otjen and Otjen, which expanded into real estate. Later, the firm was taken over by Theobald's sons, Henry and Chris. It is still in business today.

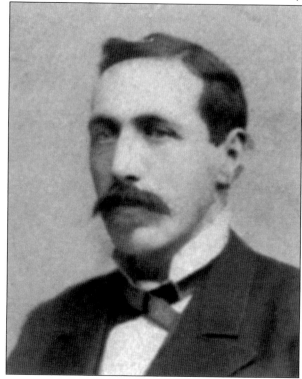

Three

THE CHURCH
AND SCHOOLS

Distinct ethnic groups started Bay View's churches. St. Luke's Episcopal and Trinity Methodist were started by English immigrants; St. Lucas Lutheran, St. Augustine Catholic, and Bethel Evangelical were founded by Germans; and Irish immigrants formed Immaculate Conception Catholic Church. The first religious services were held in residents' homes or on the grounds of the Milwaukee Iron Company, which then donated land for the establishment of the churches. Only one of those original churches still stands: the Welsh Church at 2739 South Superior Street.

The pioneer government set aside land for education. Bay View's "little red schoolhouse" was built in 1873 at what is today 2523–2541 South Wentworth Avenue. It provided primary grades and two years of high school. The brick Italianate building was razed around 1901. The vacant lot was a playground until 1954, when four residences were built.

Many churches started their own schools to provide a Christian education. Although most of those old school buildings have survived to this day, some churches have consolidated their schools due to dwindling enrollments following the post–World War II baby boom. Some of the schools are vacant or are being used for other purposes.

The same is true of the public schools. In 2010, Fritsche Middle School was closed and the students moved to Bay View High where the Fritsche name has been retained. In 2011, Dover Street School and Tippecanoe School were closed and then combined in the Fritsche building for the 2011–2012 school year.

One of Bay View's most famous landmarks is the Iron Well in the 1700 block of East Pryor Avenue. The artesian well was drilled in 1883 to provide fire protection for the "little red schoolhouse" located nearby. It is the only well left in Milwaukee and a pump brings water to the surface. People come from all over the city to fill jugs with fresh spring water that is monitored several times a year by the Milwaukee Health Department. The well was designated as a historic structure by the City of Milwaukee in 1987.

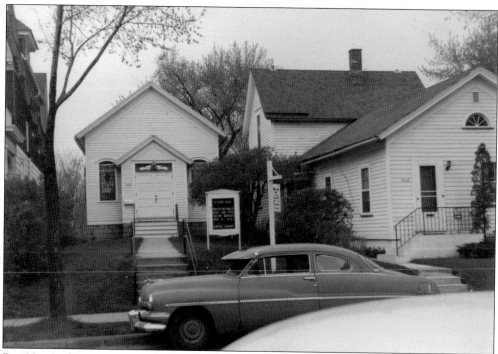

Bay View's oldest surviving church is the Welsh Church at 2739 South Superior Street built by Welsh immigrants in 1873. From 1909 through 1956, it was South Shore Lutheran Church, pictured here.

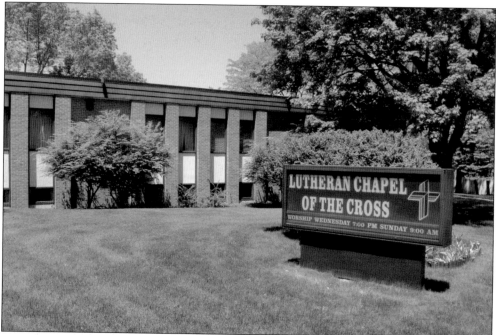

In 1958, the congregation built a new church at 3353 South Whitnall Avenue and changed its name to Lutheran Chapel of the Cross. The Christian Science Society purchased the old church and still occupies the building. (Courtesy of the author.)

Immaculate Conception Catholic Church was founded as an Irish parish in 1871 on land donated by the Milwaukee Iron Company. This Neoclassical church, designed by Buemming & Dick, replaced the original church in 1907. This is the original entrance at 1023 East Russell Avenue before the 1959 remodeling when the entrance was moved to Kinnickinnic Avenue. The Bay View Historical Society designated Immaculate Conception as a landmark in 2006.

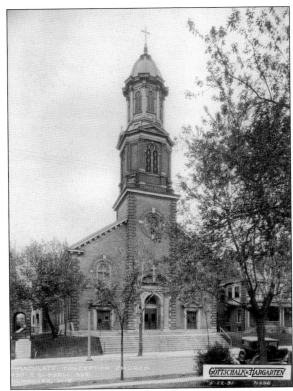

This is the original Neoclassical-style Immaculate Conception School that was built in 1885. Nicholas Backes designed a 1950 addition, which preserved some of the original school. Today, the school is occupied by Atlas Preparatory Academy.

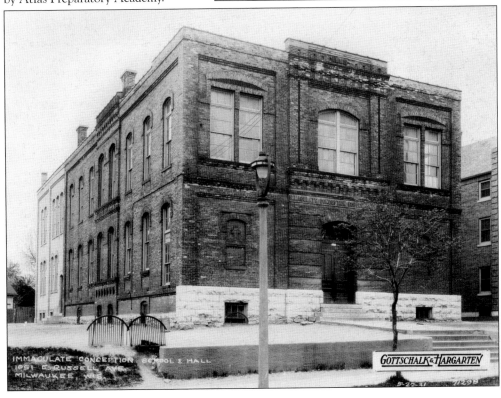

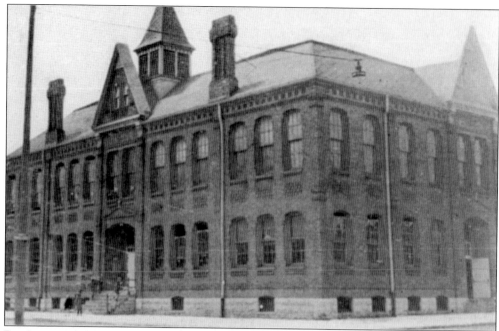

Bay View's other Catholic Church is St. Augustine parish, founded by Germans in 1887. All sermons, announcements, and records were in German until 1920. St. Augustine member Elias Stollenwerk constructed this High Victorian Gothic cream city brick building (above) at 2507 South Graham Street. He was the senior member of Elias Stollenwerk and Company, and his 1890 home can be seen at 2246 South Aldrich Street in Bay View. The Bay View Historical Society gave St. Augustine's 1887 building, which served as both school and church, landmark status in 1988. The cornerstone for the current church (below) was laid on Palm Sunday, April 12, 1908. Note the parish's three other buildings that still stand today. They are, from left to right, the original church/school, the convent (2523 South Graham Street), and the rectory (2530 South Howell Avenue).

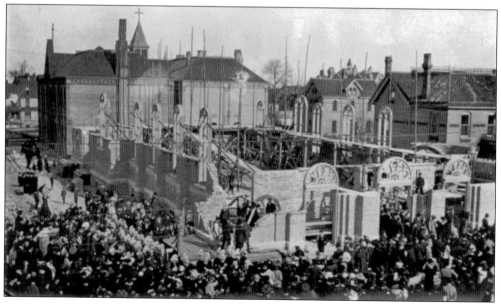

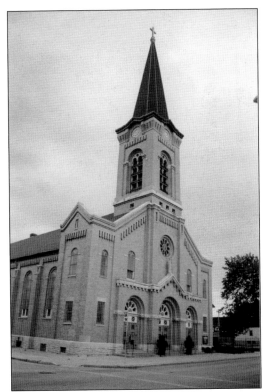

The current St. Augustine Church
(pictured on the right), built in 1908 at 2512
South Howell Avenue, was designed by Bay
View architects Peter Brust and Richard
Philipp in a Romanesque-influenced
design. Another German congregation was
St. Lucas Evangelical Lutheran Church.
Their original wooden church was built
on land donated by the Milwaukee Iron
Company on the corner of Kinnickinnic
and Logan, although it is not clear which
corner that was. In 1879, that church was
moved to 2605 South Kinnickinnic Avenue
and then was replaced in 1888 by the
present cream city brick Gothic Revival
church. The church was given landmark
status by the Bay View Historical Society in
1988. The old wooden church was moved
to 2588–2590 South Burrell, where it is a
private residence. (Courtesy of the author.)

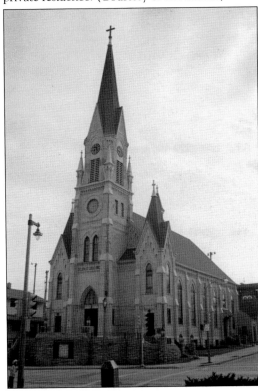

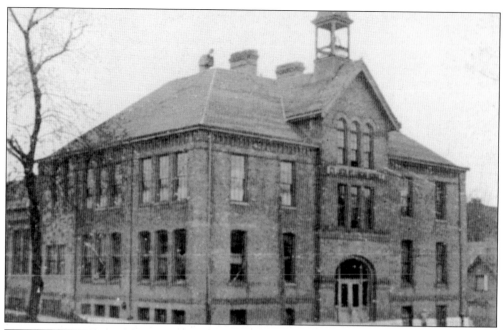

In 1891, the St. Lucas congregation constructed a school across the street from the church at 648 East Dover Street. Following a fire in 1918, the building was renovated and enlarged. This is that building, most of which was demolished, except for the auditorium, and rebuilt in 1961.

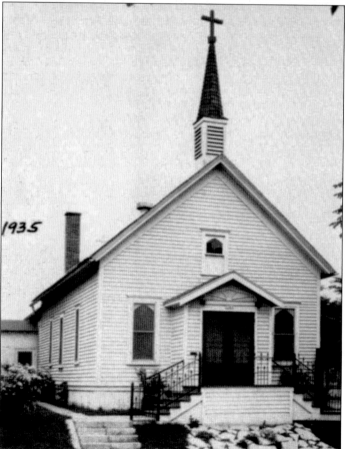

1935

A group who left St. Lucas Evangelical Lutheran Church founded Unity Lutheran Church in 1931. They purchased a house on the southwest corner of Herman and Oklahoma addressed at 3103 South Herman Street and remodeled it into this chapel. (Courtesy of Unity Lutheran Church.)

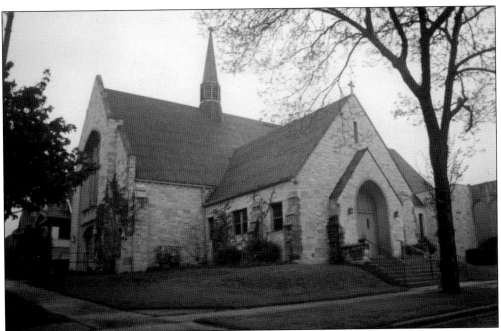

By 1939, Unity's congregation had outgrown the chapel. It was demolished and replaced by a Lannonstone Gothic Revival edifice addressed at 1025 East Oklahoma Avenue. Continued growth required an addition in 1949 that was built perpendicular to the 1939 church. In 1967, an educational wing was added to the west of the church. (Courtesy of Unity Lutheran Church.)

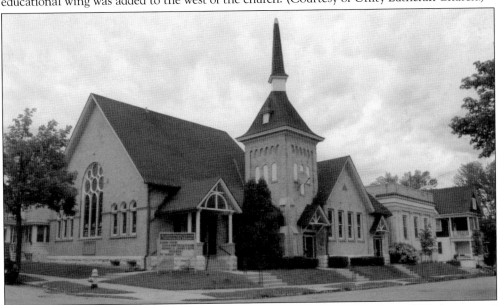

Germans founded Bethel Evangelical Church in 1883 in Walker's Point. In 1897, they moved into this Victorian Gothic-style cream city brick church designed by Crane and Barkhausen and constructed by Bay View's Meredith Brothers Construction Company at 2392 South Woodward Avenue. In 1968, they merged with Trinity Methodist Church at 2772 South Kinnickinnic Avenue to form Bay View United Methodist. Today, Iglesia Hispana Adventista Del Septimo Dio, Milwaukee, owns this church. (Courtesy of the author.)

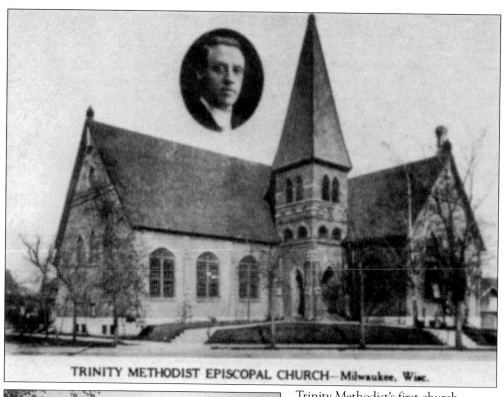

TRINITY METHODIST EPISCOPAL CHURCH—Milwaukee, Wisc.

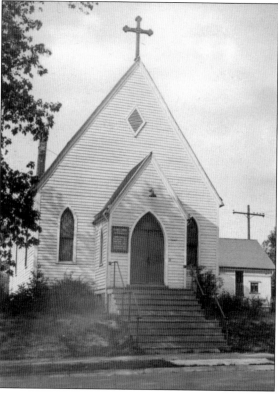

Trinity Methodist's first church was built on land donated by the Milwaukee Iron Company at what today is 2471–2473 South Wentworth Avenue. In 1887, the congregation built this Victorian Gothic cream city brick edifice at 2772 South Kinnickinnic Avenue. In 1968, the Methodist and Evangelical United Brethren denominations (page 41) merged to form Bay View United Methodist Church. The Bay View Historical Society designated Bay View United Methodist as a landmark in 1984.

English immigrants who held their first services in steel mill worker John T. Meredith's (page 33) home, at 607 East Lincoln Avenue, founded St. Luke's Episcopal Church. The congregation took its name from Meredith's home church in Bilston, England. This was St. Luke's original church, built in 1872 at 2625 South Clement Avenue. (Courtesy of Joan Luetzow.)

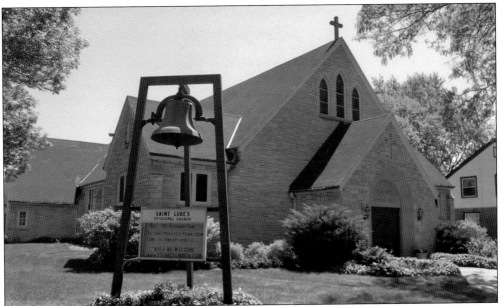

In 1951, St. Luke's Episcopal congregation constructed this new church at 3200 South Herman Street. The old church at 2625 South Clement Avenue became the home of the Bay View Gospel Church until it was razed in 1963 and replaced by an apartment building. The old St. Luke's parsonage, however, still stands at 1114 East Russell Avenue. (Courtesy of the author.)

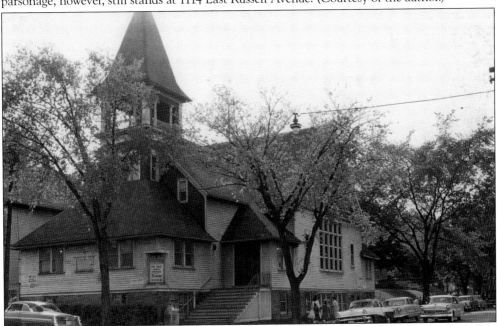

Bay View's Baptist congregation was organized in 1892. Two years later, they built Bay View Baptist Church in the Gothic Revival style at 2701 South Logan Avenue. In 1958, the congregation moved to 3800 South Howell Avenue and this church was purchased by the Bay View Assembly of God, which remained until 1969 when they moved to the old Bethel Evangelical Church on Conway and Woodward. This church was razed in 1969 and replaced with a contemporary 31-unit apartment complex.

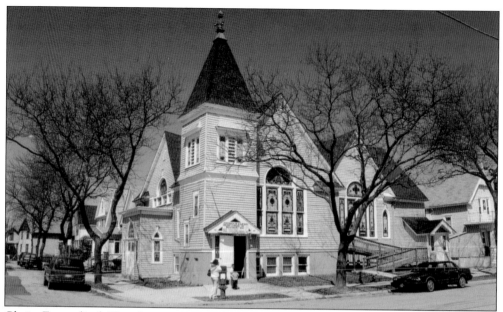

Christ Evangelical Church was organized as a German congregation in 1895. The next year they built this wooden clapboard Gothic Revival church at 2644 South Pine Avenue. When the congregation moved to 915 East Oklahoma Avenue in 1940, they sold this church to the Hungarian Evangelical and Reformed Church. That congregation remained until 1982 when they sold the church to the current owners, Asamblea de Iglesias Pentecostales de Jesucristo, Incorporated.

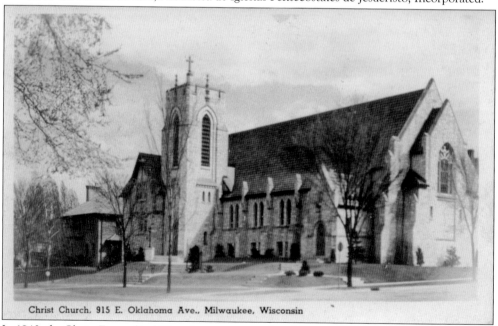

Christ Church, 915 E. Oklahoma Ave., Milwaukee, Wisconsin

In 1940, the Christ Evangelical Church congregation hired Hugo Haeuser to design this limestone Neo-Gothic Revival church at 915 East Oklahoma Avenue. The congregation's original name was Deutsche Evangelische Christus Gemeinde with all services and business conducted in German. During World War I, the congregation changed its name to Christ Evangelical Church, in keeping with a nationwide trend to eliminate German references.

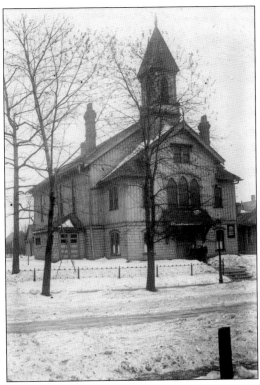

The original Immanuel Presbyterian Church built Grace Presbyterian Church in 1872 on land donated by the Milwaukee Iron Company. The church, which was located on the east side of Winchester Street, was originally named Bethany Presbyterian Chapel. The name was changed in 1884 to Grace Presbyterian Church. Although the original church was enlarged in 1910, by 1915 a new church was required. It was built for $12,000 in 1916, at 2931 South Kinnickinnic Avenue. The congregation had a high percentage of Masons, which explains why the red brick, flat-roofed, Neoclassical-style building resembles a Masonic lodge. (Courtesy of Don Crysdale.)

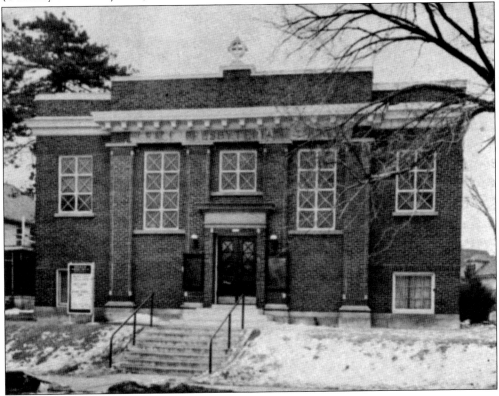

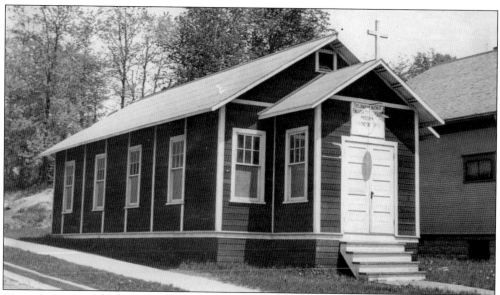

The Wisconsin Synod–built church, shown above on the southeast corner of Delaware and Meredith in 1916, had no utilities, which meant no water or restrooms. A wood-burning stove provided heat and eventually electric lights were installed. Although the congregation was organized as the Delaware Avenue English Lutheran Church, it incorporated in 1921 as Messiah English Evangelical Lutheran Church. In 1922, the congregation purchased land on the southeast corner of Kinnickinnic and Fernwood and built a church addressed at 3208 South Kinnickinnic Avenue (below) and a parsonage on the lot to the south at 3214 South Kinnickinnic. By 1959, a larger church was needed so land was purchased two blocks to the west. The Delaware Avenue church was razed in 1922, but this Kinnickinnic Avenue church and the parsonage are still standing. Today, the St. Germain Foundation owns this church. (Courtesy of Messiah Lutheran Church.)

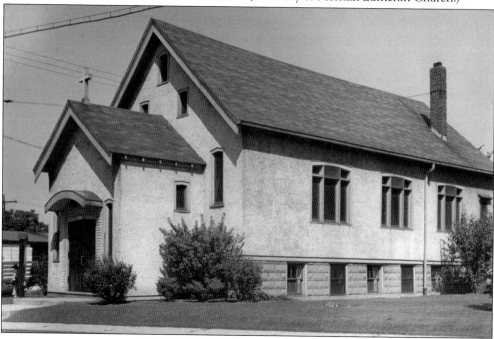

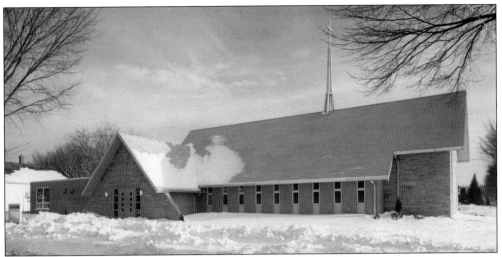

In 1962, the congregation of Messiah Lutheran Church dedicated this new edifice at 2015 East Fernwood Avenue (above). Thomas H. Stemper (1883–1978) was a teacher and organist. In 1911, he purchased the bankrupt European Statuary and Art Company at 1125 East Potter Avenue. Two years later, he purchased Milwaukee Church Supply, another bankrupt company. In 1946, he incorporated the two as T.H. Stemper Company. During the early years, Stemper's statuary division manufactured statues in all sizes up to life-size. That highly skilled workforce came from southern Italy and used a special plaster recipe that was centuries old. In the c. 1970 photograph below, founder Thomas Stemper (left) and his son Dan are at work in the shop. Today, the family's third generation is still in business at the original Potter Avenue location, where it has earned a national reputation in the religious-goods field. (Courtesy of Messiah Lutheran Church and Dan Stemper Jr.)

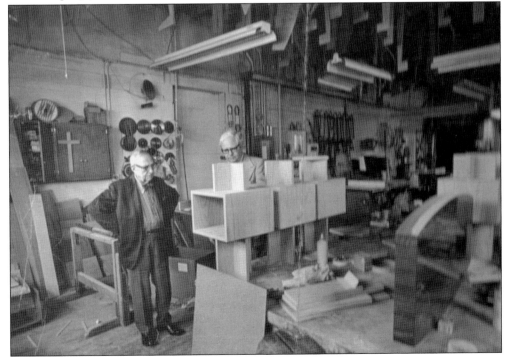

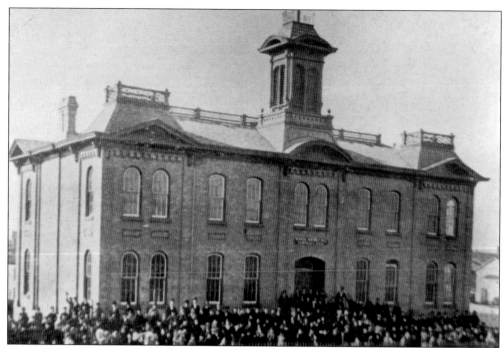

Bay View's "little red schoolhouse" was built in 1873 at what today is 2523–2541 South Wentworth Avenue. The brick Italianate building contained the primary grades through two years of high school. It was razed around 1901, and the vacant lot was known as the Beulah Brinton playground until 1954, when four residences were built.

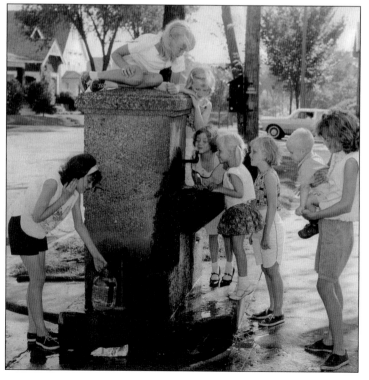

One of Bay View's most famous landmarks is the Iron Well in the 1700 block of East Pryor Avenue. It is the only well left in Milwaukee, and people come from all over the city to obtain fresh spring water. The artesian well was drilled in 1882–1883 to provide fire protection for the "little red schoolhouse" located nearby. Today, a pump is used to bring water to the surface and the Health Department monitors the water quality several times a year. The well was given historic status by the City of Milwaukee in 1987.

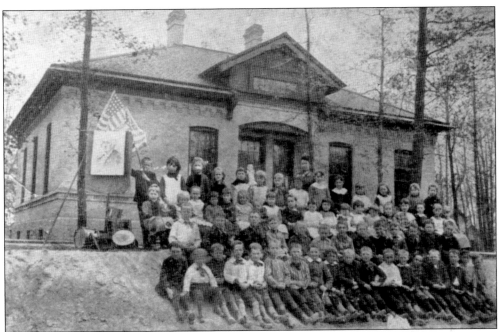

In September 1883, the Village of Bay View purchased 12 lots for a school, which was built in 1885 by Bay View builder Anton Stollenwerk. It was nicknamed the "Bird's Nest School" because of its elevated location in the woods. The "Bird's Nest School" was replaced in 1889 by the cream city brick Dover Street School, 619 East Dover Street. It was designed by Walter A. Holbrook, a partner with Edward Townsend Mix and constructed by Bay View builder Martin Davelaar. The school was designated as a Bay View Historical Society Landmark in 2001. Dover closed in June 2011 and merged with Tippecanoe School. Both schools retain their separate identities in the vacant Fritsche Middle School building at 2937 South Howell Avenue.

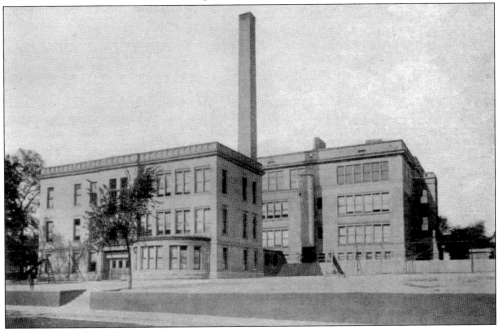

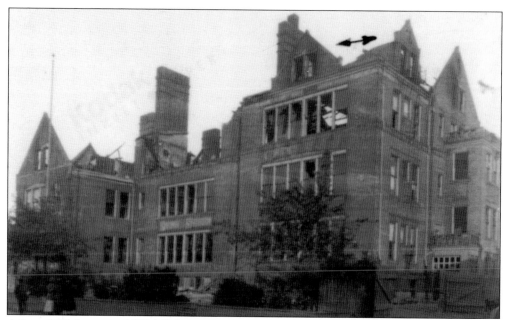

A June 1910 fire caused $23,143 damage to Dover Street School. The fire reportedly started on the fourth floor of the live-in custodian's quarters. The arrows show where the fire started. During reconstruction, the school's Queen Anne features were removed, resulting in its flat roof.

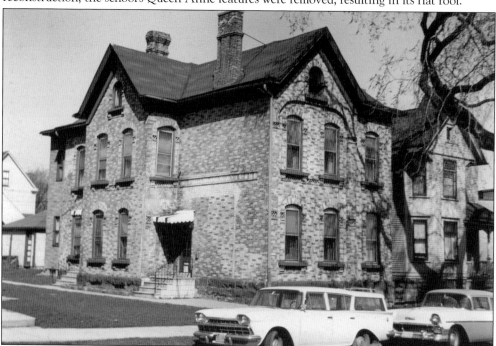

This Italianate cream city brick home (seen here around 1960) was built in 1880 at 2649 South Kinnickinnic Avenue, but in the 1890s it was moved to its current location at 2621 South Lenox Street. Rycraft, a contractor who built many schools, constructed it. His five-acre property upon which this house was originally constructed was considered for the school that eventually became the Bird's Nest School in 1885.

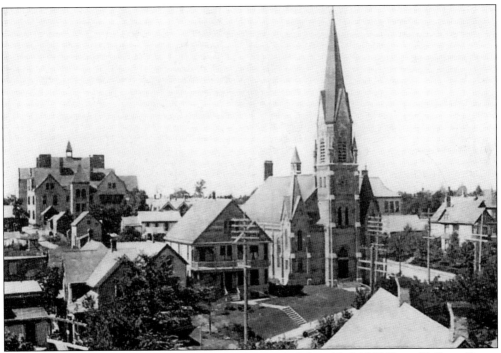

This pre-1910 photograph was taken from the roof of the old Odd Fellows Hall on Potter and Kinnickinnic. At left is Dover Street School before the fire, and at right is St. Lucas Lutheran Church.

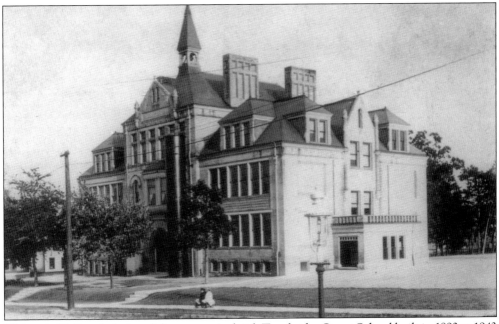

Walter A. Holbrook designed the cream city brick Trowbridge Street School built in 1893 at 1943 East Trowbridge Street. This photograph was taken before two later additions. The school's most famous student was actor Spencer Tracy, who attended Trowbridge before World War I. The Bay View Historical Society designated Trowbridge Street School as a historic landmark in 1994.

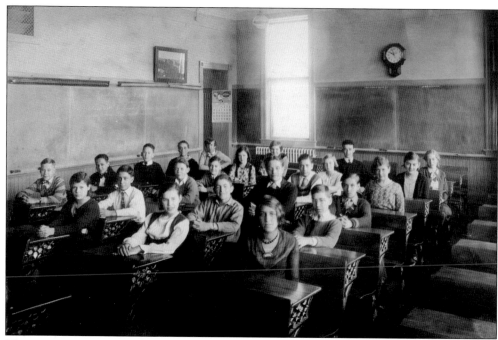

Thirty-one years separate these two eighth-grade graduation photographs from Trowbridge Street School. The top photograph is from January 1931. Elizabeth Morgan is the woman in the dark dress on the left side of the classroom. Behind her is the principal, Miss Thiese. Named for Elizabeth Morgan in 1927, Morgan Park is a triangle bounded by Kinnickinnic Avenue, Pennsylvania Avenue, and Holt Avenue. The bottom photograph is the class of May 1962. At left are principal Carl Wilke and teacher Miss Mages.

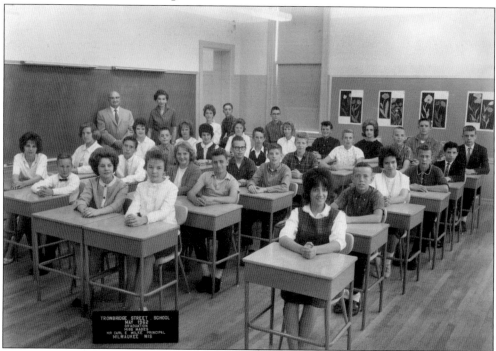

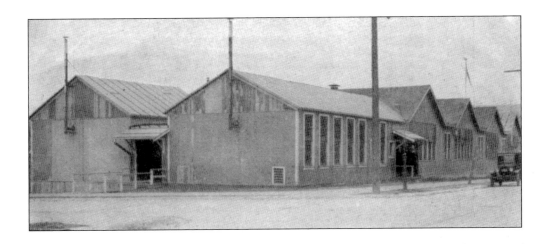

In 1888, James Douglas named his heavily wooded real estate development Fernwood. Thomas Lathrop Kennan named many of Fernwood's streets for eastern and Midwestern states (Delaware, Illinois, Indiana, New York, Ohio, and Pennsylvania). In 1891, Theobald Otjen, another real estate investor, named Rhode Island Avenue and Vermont Avenue. The Town of Lake built Fernwood's original school in 1895 on the southwest corner of Fernwood and Pennsylvania. It lacked indoor toilets and was described by Bay View alderman Paul Gauer as a "wooden fire trap" when the Fernwood area became part of Milwaukee in 1924. One of the first orders of business was to provide a modern school. The original school was torn down and replaced with these 14 temporary wooden barracks (above) on the northwest corner of Pennsylvania and Falling Heath Place. The new school (below) at 3239 South Pennsylvania Avenue was designed by Milwaukee Public Schools architect G. Wiley and opened in September 1928. Today, Fernwood is a kindergarten-through-eighth-grade Montessori school. (Courtesy of Milwaukee Public Schools.)

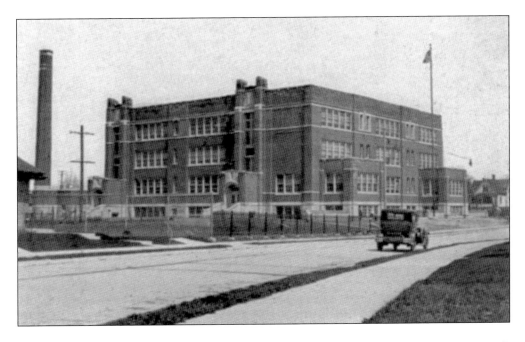

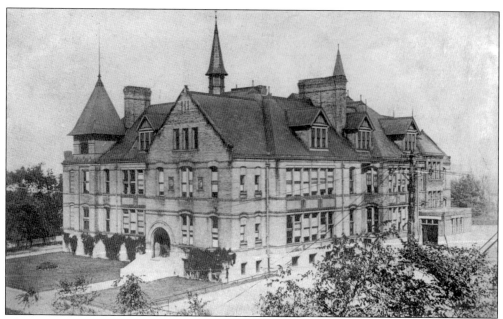

The Queen Anne–style 12th District School was built in 1897 between Mound Street and Winchester Street at 2148 South Mound Street. The land was purchased from Charles and Henry Lenck, owners of Lenck's Hardware at 2499 South Delaware. The school was later renamed Mound Street School. It closed in 1979 and was converted in 1983 to the senior housing Winchester Village at 2147 South Winchester.

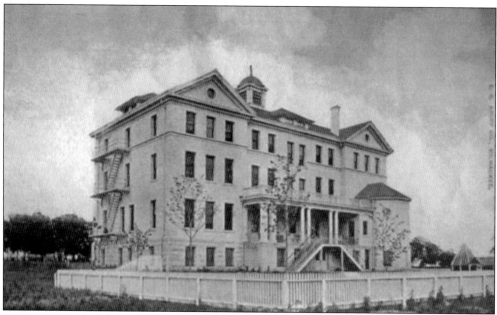

St. Mary's Academy, seen here before the 1921 and 1931 additions, was designed by Milwaukee architect Peter Brust in 1904. The high school for girls closed in 1991, shortly after nearby Thomas More High School for boys went coed. The Sisters of St. Francis of Assisi renovated St. Mary's and founded the Marian Center for Nonprofits. The building at 3195 South Superior Street is a Milwaukee County and State of Wisconsin Landmark. (Courtesy of Anna Passante.)

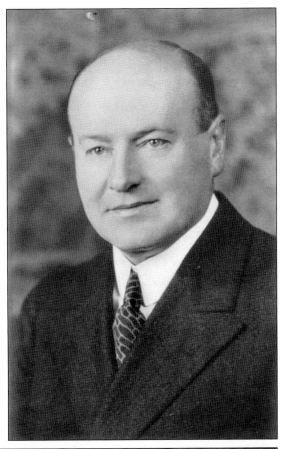

Bay View High School was organized in September 1914 in a one-building barracks along East Russell Avenue between Pine and Lenox. Gustave Armen Fritsche (1878–1939) was the principal, serving for 25 years until his untimely death in 1939. Fritsche came to Bay View from South Division High School where he taught history as well as English, German, Latin, and Greek. He was very active in the Bay View community and held positions in military, veteran, church, and civic organizations. His home can be seen at 1639 East Pryor Avenue. The crude accommodations in the barracks consisted of cold, drafty classrooms, poor lighting and cold showers. The crowded conditions are evident in this 1918 photograph.

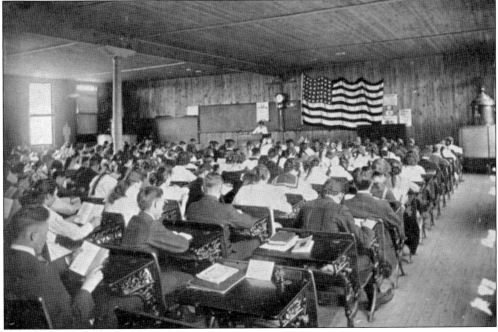

More buildings were added to Bay View High School's barracks, and they reached capacity by 1917. The barracks were affectionately nicknamed "Fritsche's Foundry," in reference to Bay View's steel mill. In 1917, construction began on a new school just south of the barracks on Lenox Street in the same block.

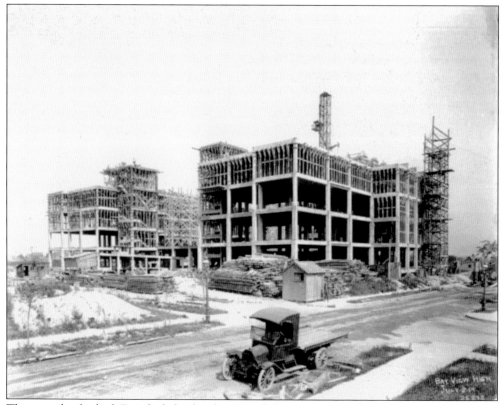

The new school, which Fritsche helped to design, took five years to complete, due to World War I and the shortage of materials after the war. (Courtesy of Milwaukee Public Schools.)

Upon Fritsche's death in 1939, vice principal Bernhard C. Korn (1890–1976) became Bay View's principal, a post he held until 1960. Korn grew up in Bay View and had a history degree from Marquette University. The Milwaukee County Historical Society published his history of early Bay View, titled *The Story of Bay View.*

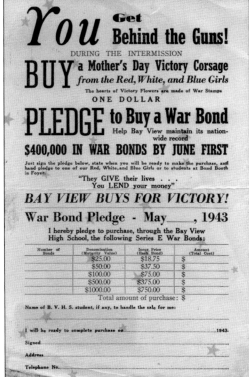

During World War II, the Victory Corps was formed at Bay View High so students could participate in the war effort by selling war bonds and collecting scrap metal and paper for recycling. Bay View led the nation's schools in the sale of war bonds (over $2 million) and the collection of scrap (1,527 tons). To reward students for their success, the Student Government Association (SGA) was formed in 1947.

Student Government Association (SGA), with an assembly, student board, and student court, was established for students to develop their special talents and to gain a better sense of responsibility while providing for the needs and interests of the student body. SGA designed a student handbook and worked to maintain good relations between students and faculty. In 1955, honor study halls, where no teachers were present, were established. Louise Tesmer (pictured on the left) graduated from Bay View in 1960. She is an attorney and was a member of the Wisconsin State Assembly from 1973 to 1989, when she resigned to become Milwaukee County circuit court judge, a post she holds today. Rosemary Potter (below) is a 1970 Bay View High graduate who was president of the SGA Assembly. Here, she is receiving the gavel from Principal Arthur Showers, at left. Potter was a teacher and then a member of the Wisconsin State Assembly (D) from 1989 to 1999. Today, she is director of government relations for the University of Wisconsin Colleges and the University of Wisconsin Extension.

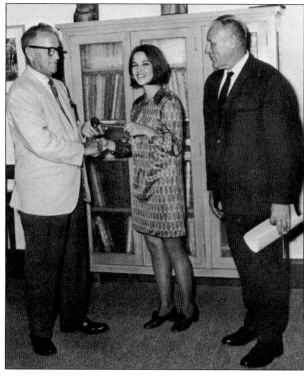

Bay View High's school newspaper and yearbook, the *Oracle*, took its name from the oracle at Delphi in ancient Greece, a shrine where the clergy obtained information from deities. Today, the school newspaper is called *Redcat Reflections*.

Bay View's school colors of scarlet and black were adopted in 1916. The athletic teams, originally the Silverites and then the Bays, became the Redcats in 1950. The school had only male cheerleaders before 1960, although in this 1957 photograph, the school's mascot, Reddy Redcat, is a girl. Since 1960, all cheerleaders have been girls.

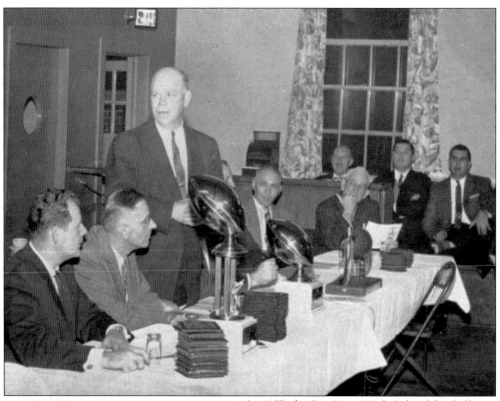

In 1957, the Bay View High School football team with a 6-2 record shared the city conference championship with Boys' Tech. Pictured from left at the fall sports banquet are Coach Francis "Red" Mierzwa, principal Bernhard Korn, *Milwaukee Sentinel* sportswriter Lloyd Larson, athletic director Merle Schoeller and school engineer Arthur Nuernberger.

On November 2, 1962 Bay View High School won its final football game of the season, giving the Redcats a 6-2 record and a share of third place in the City Conference. During the game, star end and all-city candidate Ted Jarzyna was injured and died afterwards. Jarzyna's energy and humor had been appreciated by both students and teachers. His death shocked Bay View, and his jersey number 38 was retired from Bay View football.

Bill Matthei was a physical education teacher at Bay View High from 1927 until 1971. He also coached track, cross-country, fencing, ice-skating, hockey, and established the school's gymnastics program. However, he is most associated with track and cross-country. Bay View's track team won the Wisconsin State Championship in 1928 during Matthei's first year as coach. In 1966, his final year as head coach, Bay View again won the state title. In cross-country Matthei's teams won state championships in 1931, 1943, 1944, 1945, 1959 and 1960. In various sports that Matthei coached his teams won 11 city championships, 8 state titles, and 5 Midwest championships. In the photograph below, Coach Matthei urges Ron Winkler on during the 1965 South Side Cross-Country Championships in Jackson Park.

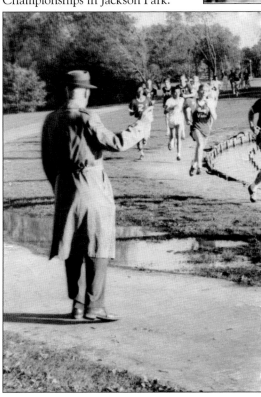

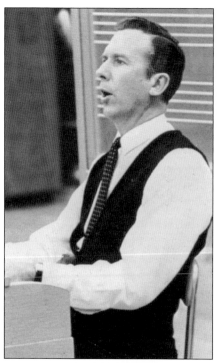

Ray Dietrich has inspired generations of Bay Viewites and residents of Milwaukee's south side. Dietrich graduated from Bay View High in 1941 and attended the University of Wisconsin-Milwaukee, where he received a bachelor's degree in music education in 1948. The following year, he received his master's of music degree from the University of Michigan. He joined Bay View's music staff in 1949 and remained for 35 years until 1984. During that span, he was chairman of the music department and director of choral activities. He was responsible for the production of Bay View High's spring musicals. Pictured below is *My Fair Lady* from 1964. Dietrich directs the Bay View Alumni Choir, which was formed in October 2006 and performs a winter and a spring concert. He is also music director emeritus at Ascension Lutheran Church, 1236 South Layton Boulevard, where he served as music director from 1951 to 1997. In 2009, Dietrich received the Lifetime Achievement in Music Award from the Civic Music Association of Milwaukee. In May 2011, Bay View High School's auditorium was renamed the Raymond Dietrich Auditorium.

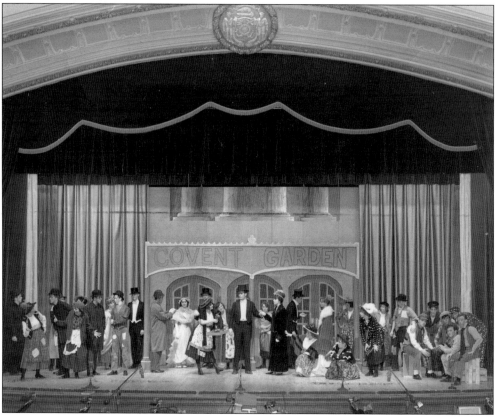

Theresa Statz had a long career at Bay View High. She taught physical education in the 1930s before becoming dean of girls, head guidance counselor, and chair of candidates for graduation. She had contact with the schools of incoming students and directed those students in choosing programs suited to their needs and capabilities. She also arranged conferences with parents and was in charge of all testing.

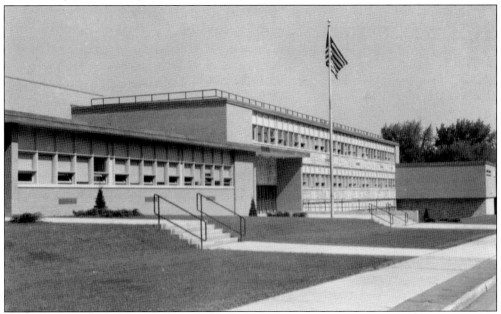

Fritsche Junior High School 2937 South Howell Avenue opened in September 1963 in response to the post–World War II baby boom. The school was named for Gustave Fritsche, Bay View High's first principal. In 2010, Fritsche closed and the students were sent to Bay View High. When Dover Street School and Tippecanoe School closed in June 2011, they moved to the vacant Fritsche building, where they retain their separate identities. (Courtesy of the author.)

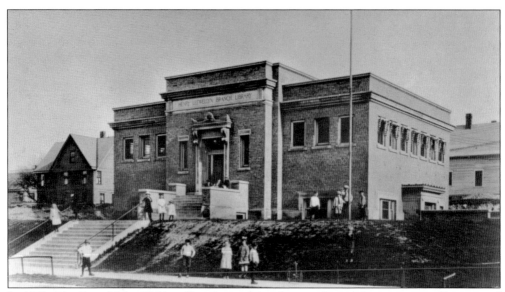

In 1913, Silas J. and John T. Llewellyn donated four lots on the southeast corner of Lenox and Russell in memory of their father who had owned a grocery store on the southeast corner of Russell and Wentworth. The architects were Van Ryn and DeGelleke, who designed the Classical Revival Llewellyn Library built on a hill at 907 East Russell Avenue (above). A contemporary addition, built across the front of the library in 1959, eliminated the hill and most of the Classical revival features (below). When the new Bay View library was opened in October 1993 at 2566 South Kinnickinnic Avenue, this building was leased by Bay View High School as the Redcat Academy. High school graduates from ages 18 to 21 can learn life and job skills and also earn credits for doing volunteer work.

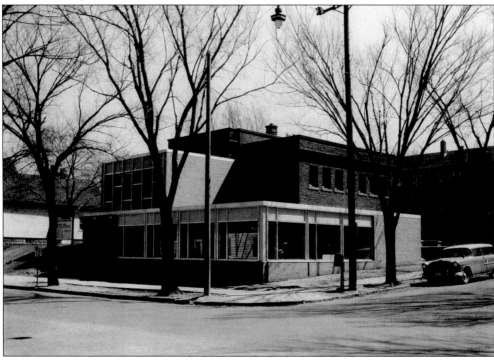

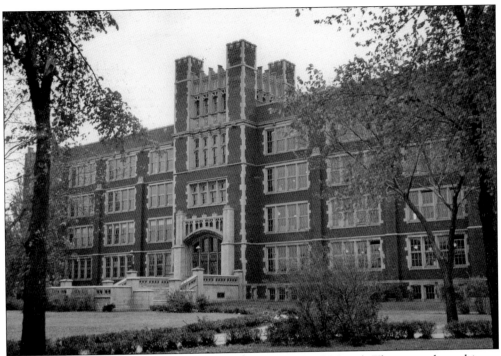

Van Ryn and DeGelleke also designed Bay View High School (above). They were the architects for Milwaukee Public Schools who also designed Washington High School and Riverside High School. The four-story, red-brick, Elizabethan-style or Collegiate Gothic–style Bay View High School at 2751 South Lenox Street was opened in September 1922 and nicknamed the "Castle on the Hill." An interesting feature of the school is the line of gargoyles circling the building at the fourth level. In 1975, an addition to the north side of the school added classrooms and a 1,200-seat gymnasium (below). Unfortunately, the addition covered the school's main entrance and the adjacent parking lot destroyed the beautifully landscaped campus. (Courtesy of Milwaukee Public Schools and the author.)

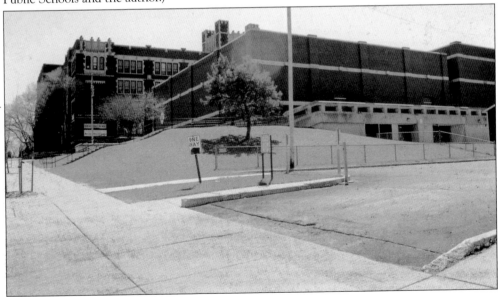

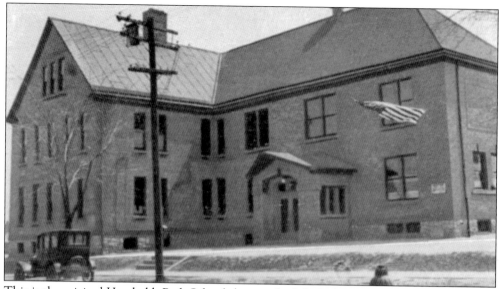

This is the original Humboldt Park School that was built by Lake Township. In 1925, this area of the town of Lake, which was south of Humboldt Park, became part of the city of Milwaukee. Wooden barracks were constructed to accommodate the increased enrollment from Bay View pupils. In 1929, Milwaukee Public Schools architect G. Wiley designed the current red brick school, which was constructed on the same site at 3230 South Adams Street on the site of the old school (below). The school is bordered by Adams Street on the west and Quincy Avenue on the east. One block east is Taylor Avenue, giving students a mini lesson in early American presidents. Today, Humboldt Park School is a Milwaukee Public Schools kindergarten-through-eighth-grade charter school with a focus on reading, technology, and English as a Second Language (ESL). Student background is quite diverse, with 16 different languages spoken by its students. (Courtesy of Milwaukee Public Schools.)

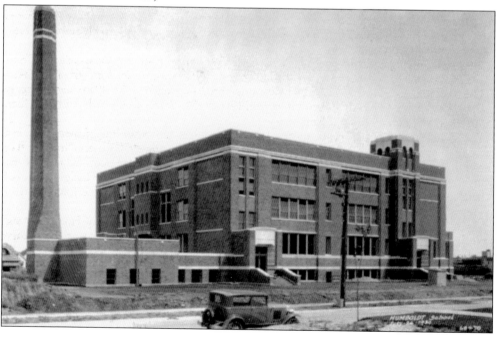

Four

LITTLE ITALY

Following the pioneer era, Bay View's inhabitants came mainly from Great Britain and Germany. In 1900, Italians started moving into the area bounded by Russell Avenue on the south, the railroad tracks on the west, and the steel mill on the north and east. They supplanted the other ethnic groups as those ethnic groups moved to newer areas of Bay View. The Italian population grew from 43 in 1905 to about 2,000 in 1920, and this area became known as Little Italy. Most of the Italians came from northern Italy, in contrast to Milwaukee's Third Ward Italians who came from Sicily. Many of Bay View's Italian businesses survive today.

The corner of Superior and Russell is the location of two Italian taverns. Peter Marino purchased the tavern at 2491 South Superior Street in 1924. Across the street at 2501 South Superior Street is Club Garibaldi.

The DeMarinis name is famous among pizza lovers throughout not only Bay View, but Milwaukee's entire south side. Today, there are two DeMarinis restaurants within two blocks of each other.

The most famous Italian name in Bay View is Groppi's. Giocando (1884–1956) and Georgina Groppi (1890–1985) founded Groppi's Grocery in 1913 at 2507 South Wentworth Avenue. When they retired, their children took over.

The store featured Italian pasta, olive oil, Italian sausage, and other Italian specialties, but there was more than food. Tom Groppi, son of the founders, described the variety: "In the fall of the year we sold zinfandel grapes for wine making. Father and my brother Louis did most of the work. One year they sold seven boxcar loads of grapes. We also sold kerosene lamps, hard coal briquettes, dry goods, thread, yarn, darning cotton, overalls (what we call blue jeans today). I guess you might say we were a general store."

The store closed in February 2003 but was purchased by John Nehring and Anne Finch-Nehring, who also own Sendik's on Oakland Avenue in Shorewood, and V. Richards Market on Bluemound Road in Brookfield. Groppi's is the only Italian grocery store on Milwaukee's south side.

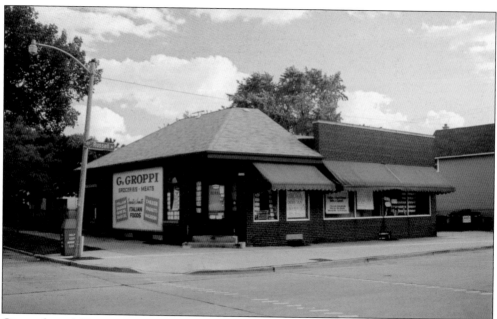

Giocando and Georgina Groppi founded Groppi's Grocery in 1913 at 2507 South Wentworth Avenue. They spoke Italian but had a rapport with the entire community. The store was a meeting place and social center with news, gossip, and politics. Today, it is the only Italian grocery store on Milwaukee's south side. It is listed on the National Register of Historic Places and the Bay View Historical Society designated Groppi's as a landmark in 2008. (Courtesy of Tom Groppi.)

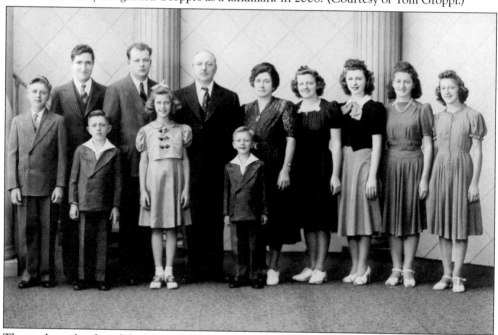

The work was hard, and the hours were long. However, there were 10 Groppi children who helped run the store. The family members in this 1939 photograph are from left to right (first row) Mario, James, Gloria, Thomas; (second row) Louis, John, Giocando, Georgina, Eleanore, Theresa, Mary, and Frances. (Courtesy of Tom Groppi.)

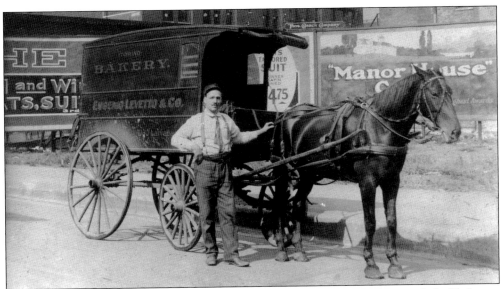

Giocando Groppi came to the United States in 1911 from Filechio in Tuscany, Italy. He began his pursuit of the American dream in Chicago, working as a baker and deliveryman for the Eugenio Levetto Bakery in Chicago (above). Groppi's Grocery offered home delivery in the early years, and credit was extended to anyone who needed it. Tom Groppi commented, "During the Depression and after, many people were carried on the books. Most paid their bills, but many could not afford to, but still we survived and remained friends." Below are some of the store's employees in the mid-1970s. From left to right are Tom Groppi; his wife, Violet; Dick Groppi, son of Lou; Mario Groppi; butcher Al Yokofich; Lou Groppi; and John Groppi. Violet performed a community service to mothers in the neighborhood by weighing their children on the store's scale in order to chart their growth. (Courtesy of Tom Groppi.)

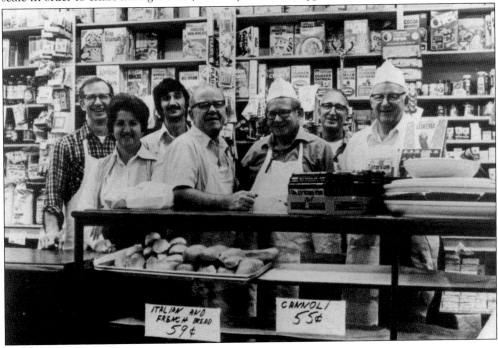

Before 1923, Italians were not welcome at Bay View's predominantly Irish Immaculate Conception parish. This racism was the foundation for the civil rights activism of the Groppi family's most famous member, Fr. James Groppi (1930–1985). Groppi led marches starting from his inner-city parish, St. Boniface Catholic Church on Eleventh and Clarke Streets. They crossed the Sixteenth Street viaduct into the predominantly white south side for over 200 consecutive days until Milwaukee adopted a fair housing ordinance in 1968. The peaceful marchers met with hate and violence on the south side. The viaduct was renamed the James E. Groppi Unity Bridge. In addition, the former Milwaukee Public Schools' Twenty-seventh Street School at 1312 North Twenty-seventh Street is scheduled to reopen in 2011 as James Groppi High School. Groppi's Grocery (below) was the gathering spot for adults and children such as this group of boys in the late 1920s. From left to right are (first row) Joe "Poppy" Decessari, Joe Travis, and Lou Groppi; (second row) unidentified, Milo Stracci, unidentified, and unidentified; (third row) Fred Marchetti, unidentified, and Savino Ceccarini. (Courtesy of Tom Groppi.)

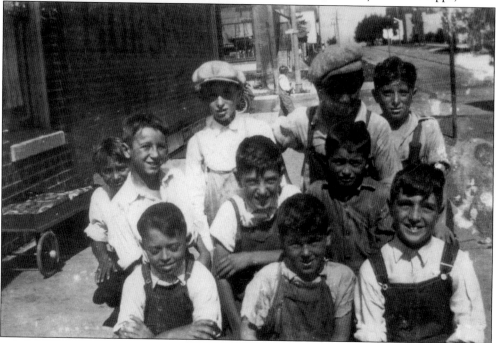

The Cactus Club, 2496 South Wentworth Avenue, features live music, but during World War I it was the headquarters for Italian anarchists. On Sunday, September 9, 1917, the group interrupted a patriotic meeting on Potter and Wentworth. Shots were fired, and two anarchists, one of whom was the leader, were killed; many were wounded. Weapons and anarchist literature were found in the headquarters. (Courtesy of Milwaukee County Historical Society.)

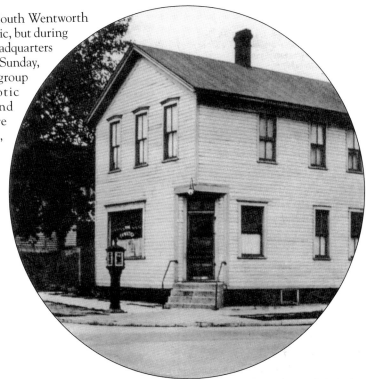

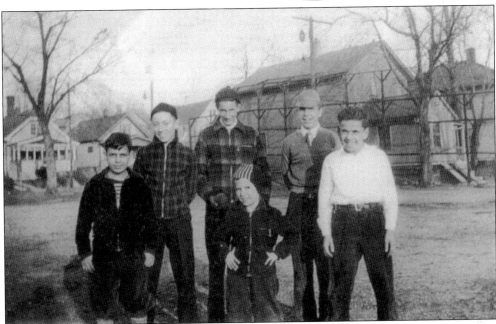

When Bay View's "little red schoolhouse" was torn down, the vacant lot on Wentworth Avenue just south of Groppi's became the Beulah Brinton Playground. In this 1940 photograph, the small boy in front is Dick Marino. The other boys are, from left to right, Ed Travis, who died in the Korean War; Don Baldini; Ray Niemer; Carl Dubla, who died in Italy during World War II; and Lou Travis, who died in Iwo Jima during World War II. (Courtesy of Tom Groppi.)

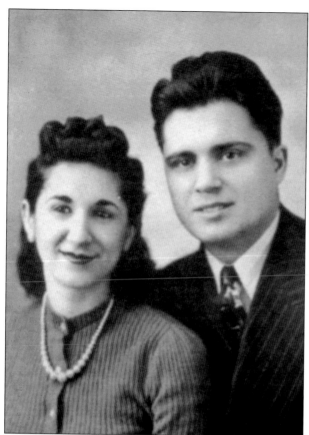

In 1950, Vincenzo "Jimmy" and Lucy DeMarinis bought a tavern at 2457 South Wentworth Avenue. They expanded it into a restaurant and offered pizza, which was becoming popular. Their four children became involved with the business, but in 1996 a family feud developed over the division of the business and the original recipes. Sons Dominic and Phil opened Dom & Phil DeMarinis Original Recipe Pizza at 1211 East Conway Street, less than two blocks away. That building (below) originally housed German POWs at Mitchell Airport during World War II. It was moved here in 1949 and named the Travis AMVETS Post Number 14 of the American Legion, for Louis Travis, an Italian veteran who died at sea in 1945 during World War II. The original restaurant continues in operation as Mama DeMarinis' Original Recipes, run by twin daughters Rosie and Josie. (Courtesy of Tom Groppi and the author.)

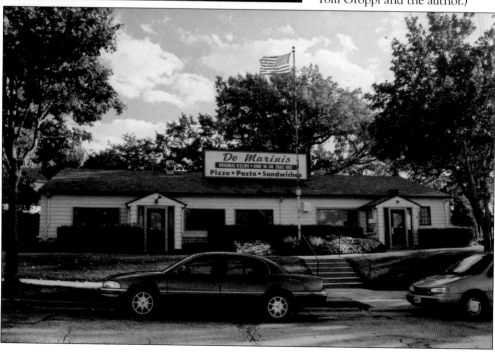

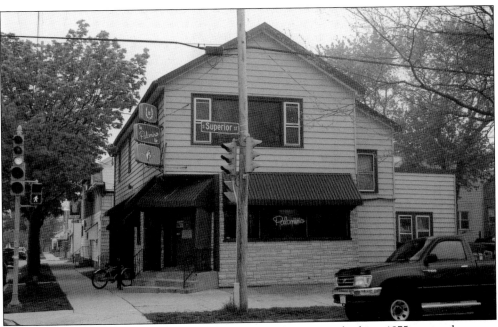

Peter Marino's Tavern (above), 2491 South Superior Street, was built in 1875 across the street from the steel mill. Mill workers who finished their shift could "tip a few" as they waited for the Cream City Car Line's horse-drawn streetcar, whose terminus was at this intersection. Today, it is The Palomino Bar. The Schlitz Brewery built Club Garibaldi (below) on 2501 South Superior Street in 1907 as an outlet for its products. In 1943, the property was acquired by the Italian American Mutual Aid Society, formed in 1908 to provide social security for Italian families. In 1992, the Bay View Historical Society awarded Club Garibaldi a certificate in recognition of its service to the Italian community. The building is listed on the National Register of Historic Places. (Courtesy of the author.)

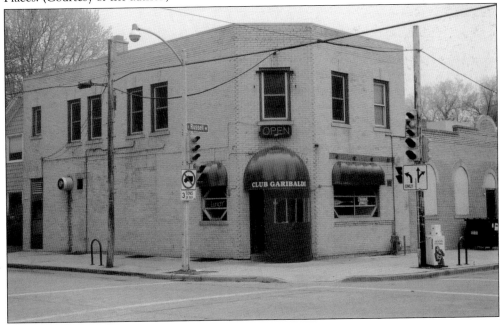

This fire station at 2455 South St. Claire Street was decommissioned in 1918, and the men moved to the fire station on Kinnickinnic Avenue. The building was converted into Milwaukee's 12th social center, named the Beulah Brinton Center. The flag-draped building, seen here on its dedication day in 1924, was razed in 1977 and replaced in 1981 by the current Beulah Brinton Center at 2555 South Bay Street. (Courtesy of Milwaukee County Historical Society.)

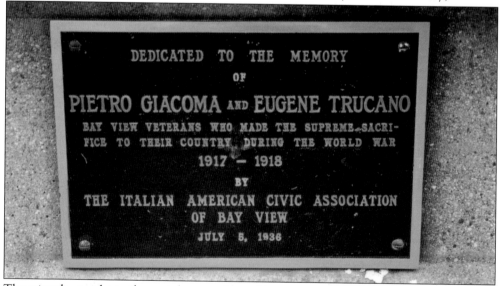

The triangle at right in the top photograph on this page contains a monument honoring Bay View servicemen Pietro Giacomo and Eugene Trucano, Italian immigrants who died during World War I. The Italian American Civic Association of Bay View dedicated the monument in 1936. (Courtesy of the author.)

Five

THE HIGHWAYS
AND BYWAYS

As agriculture was replaced by steel, the readily obtainable supply of produce in Bay View dwindled, but several entrepreneurs opened grocery stores to fill the niche. Gottlieb Patek's General Store was Bay View's largest general merchandise store from 1870 until 1895. The store still stands at 2469 South Delaware Avenue, although it was long ago converted to housing.

In 1927, Max Kohl (1901–1981) opened a food store at 630 East Lincoln Avenue (razed in the late 1980s), which he expanded into Kohl's Food Stores. Max, who was Sen. Herb Kohl's father, also started the chain of Kohl's Department Stores throughout southeastern Wisconsin.

Before automobiles and Milwaukee's 1920 zoning laws, neighborhoods were built for walking. That is why old stores are seen in residential areas. Each neighborhood had its own grocery store, butcher, candy store, bakery, drugstore, barbershop, beauty salon, shoemaker, and several saloons. The owner lived in a flat above or next to the store. Most were converted to housing long ago, but some, like Groppi's Grocery, are still operating.

Bay View's two main north–south streets, Kinnickinnic Avenue and Howell Avenue, contain an assortment of large and small businesses. Kinnickinnic Avenue has two main commercial districts. The first extends south from Lincoln Avenue for three blocks. The second extends south from the Bay View Library at Otjen Street to Clement Avenue.

Bay View was home to many nationally known companies, such as Vilter Manufacturing, Nordberg (now Rexnord), Milwaukee Valve, Jerome B. Meyer and Sons, Dings Magnetic Company, and Louis Allis.

Many of Milwaukee's streets such as Clement Avenue were paved with red bricks. When Clement Avenue lost its bricks in the early 1980s, some of the bricks were made part of the Pryor Avenue well, Rolling Mill Marker on Superior and Russell, and the bus stop on the northwest corner of Clement and Dakota. Many Bay View alleys still have their bricks.

The entire commercial area of Bay View experienced an economic decline in the second half of the 20th century, but lately this trend has reversed.

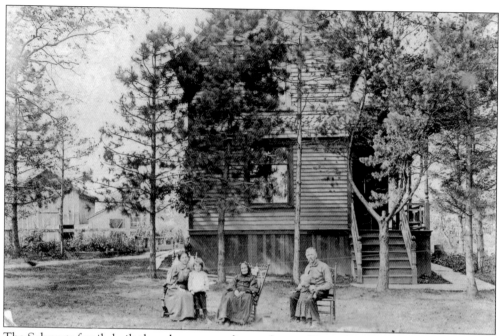

The Schwartz family built three houses on adjacent lots on Kinnickinnic Avenue. They are still standing today immediately south of Grace Presbyterian Church. Herman J. Schwartz (right) is pictured with his family in front of the house he built in 1886 at 2939 South Kinnckinnic Avenue. (Courtesy of Amy Olson.)

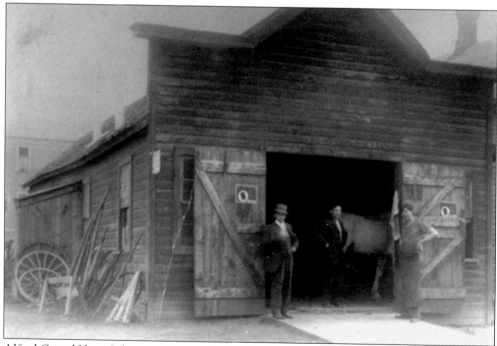

Alfred G. and Hugo Schwartz also owned this blacksmith shop (razed) that was located at what today is 501–507 East Lincoln Avenue. Alfred G. is at right in this photograph from the early 1900s. (Courtesy of Amy Olson.)

The Schwartz family had a horse stable behind their Kinnickinnic Avenue homes. Herman's sons Alfred G. and Hugo owned a second stable on Ellen Street and Hillcrest Avenue from which they operated Schwartz Brothers Excavating and Grading. Here is Alfred G. in front of that stable. (Courtesy of Amy Olson.)

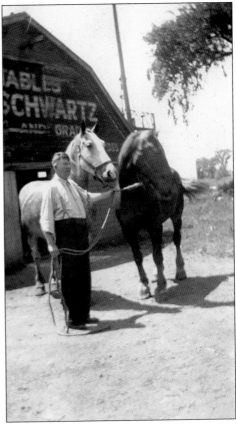

Alfred G. Schwartz (1880–1956) loved horses and bought his first horse in 1892 at age 12. Throughout his life, he bought, sold, traded, raced, and judged horses. During World War II, when rubber and gasoline were rationed, Schlitz Brewery revived the horse-drawn beer wagon. They hired Schwartz to oversee this aspect of the company's operation. He is pictured here driving a team in 1945. (Courtesy of Amy Olson.)

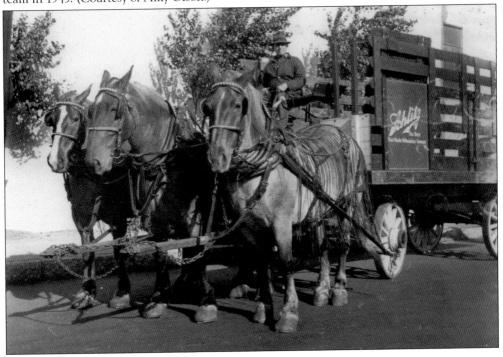

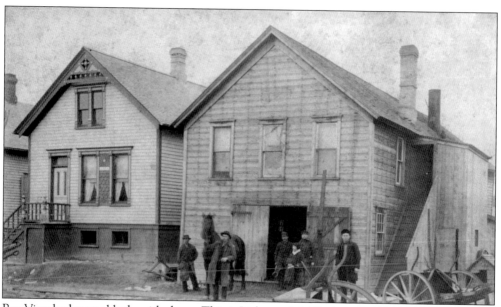

Bay View had many blacksmith shops. This is Liebenstein's Blacksmith Shop, which was on the northwest corner of Howell and Schiller across from Humboldt Park. The date of this photograph is unknown.

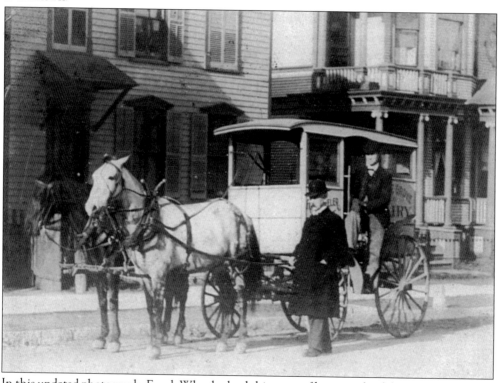

In this undated photograph, Frank Wheeler leads his team of horses as he delivers dairy products on Dover Street near Kinnickinnic Avenue, an old Indian trail named for the river that it crosses just north of Becher Street. *Kinnickinnic* is a Native American word that means "it is mixed" and refers to a blend of leaves, twigs, and bark used for smoking.

Bay View builder Elias Stollenwerk constructed both of these buildings. In 1896, his brothers Frank and Tom founded Stollenwerk Brothers Feed and Grains in the building at right (438 East Smith Street). Tom lived in the Queen Anne home at left (432 East Smith Street), which was converted to a rooming house in 1951. (Courtesy of the author.)

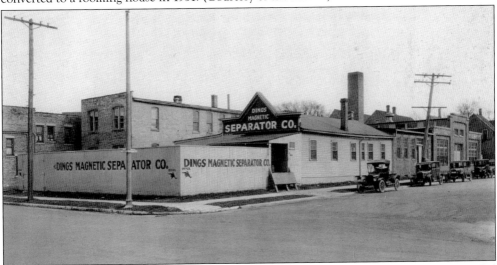

While working at Allis-Chalmers, Myron Dings developed a magnetic separator and founded the Dings Company in 1899 at 509 East Smith Street. In 1946, the company moved to West Milwaukee, where it is still in business today. Its products are used worldwide for anything that requires removal of unwanted iron and steel. Applications range from foodstuffs to ores. This old building was razed in 1958. (Courtesy of Milwaukee County Historical Society.)

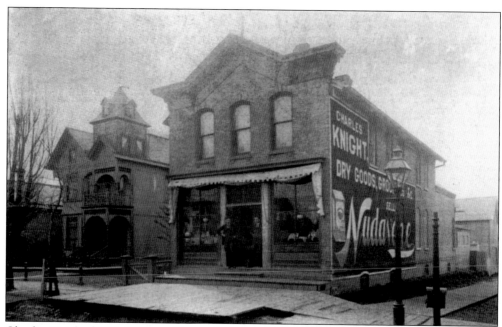

Charles Knight (1849–1930) and his wife, Josephine (1846–1937), ran Knight's General Store (at right) until 1917. It continued as a grocery store until 1940 when it became an upholstery shop. The store was built in 1881 at 1815 East Iron Street and razed in 1954. The Knights' home (left) was built in 1906 and still stands at 2707–2709 South Superior Street, although extensive remodeling in 1948 removed most of the Victorian architecture.

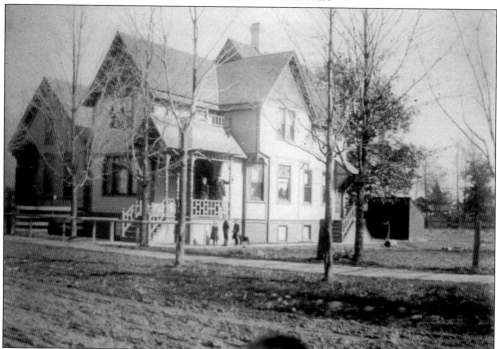

Although the exact age of this Queen Anne home at 2504 South Howell Avenue is unknown, this photograph is from 1896. In the mid-20th century, this was the home of Stoltz's Hobbyland.

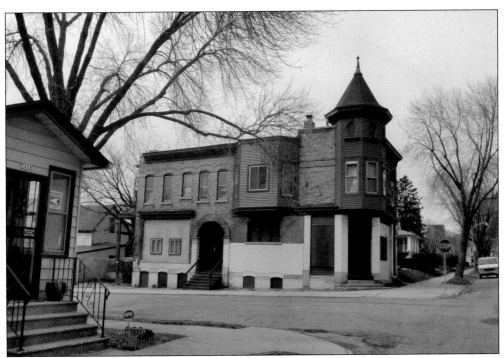

Mattuschek's Groceries and Saloon was a tied house (a tavern built by a brewery for exclusive distribution of its products) built by the Joseph Schlitz Brewing Company in 1898 at 2549 South Burrell Street. The owner was Richard Mattuschek, and his sons Harry and Robert operated it as a grocery store until around 1970 when it was converted to housing. (Courtesy of the author.)

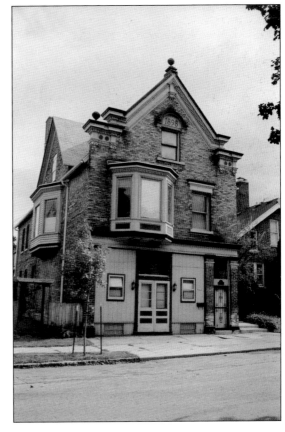

This Queen Anne–style cream city brick building at 2436–2438 South Lenox Street was designed by Milwaukee architect Peter Brust. It was built in 1898 and was the Lenox Street Home Bakery from 1930 until 1965. Today, it is a single-family home. (Courtesy of the author.)

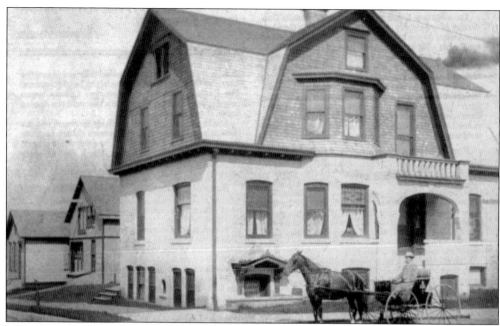

Many doctors set up practices on Kinnickinnic Avenue. In those days, doctors, just like most merchants, lived in the building where they worked. Three generations of physicians resided in the home and office (above) at 2572 South Kinnickinnic Avenue, built in1901 by Dr. Paul G. Hankwitz. Paul was joined by his father, Carl, and later by his own son Arthur. Following Arthur's death, the home was sold in 1972 and razed in 1992 to make room for the Bay View Library. The Tudor Revival home pictured below at 2445 South Kinnickinnic Avenue was designed by Milwaukee architect Alexander Eschweiler. The Meredith Brothers constructed it for $7,500 in 1903 for Dr. William A. Batchelor. Dr. Batchelor died in 1920, and the next inhabitants were Dr. Earle X. Thomson and his wife, Dorothy, from 1922 until 1941. In 1942, Dr. Joseph Halser and his wife, Dorothea, bought the property. The building, known as the Eschweiler House, was designated as a Bay View Historical Society Landmark in 2010.

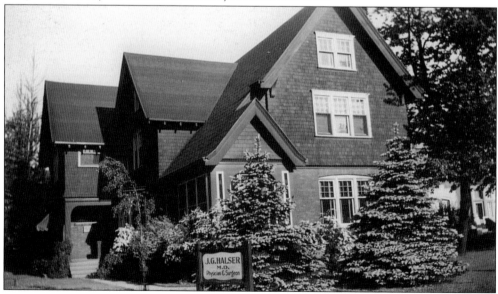

Dr. Clinton Lewis built this three-story home and office at 2519 South Kinnickinnic Avenue in 1898. His plans for a pharmacy and 10-bed hospital were abandoned when the original St. Luke's Hospital opened nearby on East Madison Street. Lewis's daughter Marian, also a physician, inherited the home in 1931. She used it as her home and office, and lived in the house until her death in 1971.

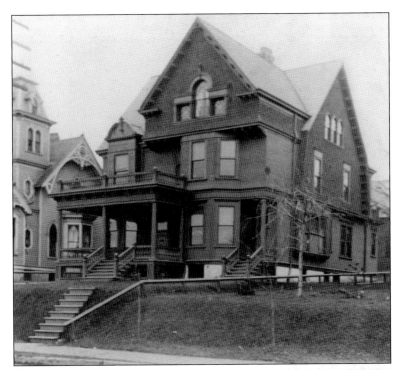

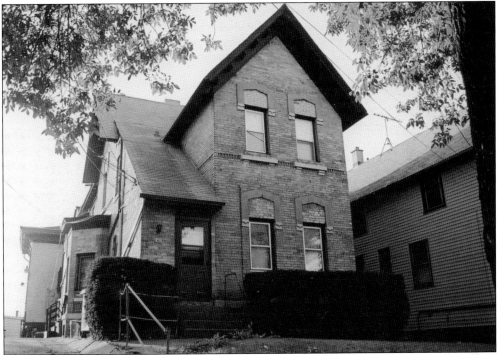

Martin Daavelaar owned this Victorian Gothic cream city brick home at 2467 South Burrell Street, which was constructed in 1886. In 1890, Davelaar built a new home for himself at 2513 South Kinnickinnic Avenue, which still stands. Davelaar owned one brickyard in Chase's Valley behind this home and a second on Pryor and Delaware, the site of today's Lewis Playground.

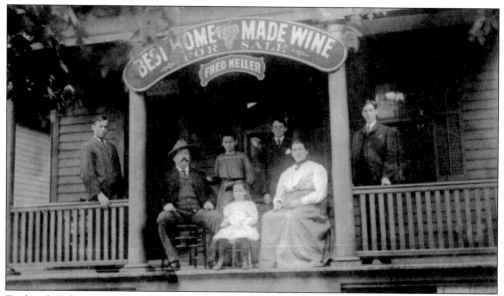

Frederick Keller (1866–1943) came to the United States from Germany in 1897. He founded the Keller Winery in 1910 at 318–324 East Deer Place. At its peak, before Prohibition, the winery is said to have produced 50 different kinds of wine. In the above photograph, Keller is second from left with his family. Today, the property contains Keller's home, the wine cellar, a stable, and some grape vines. The Keller Winery received landmark designation by the Bay View Historical Society in 2006. In the photograph below, Keller is in the wine cellar that he dug into the side of the hill to eliminate the need for artificial cooling. (Courtesy of Milwaukee County Historical Society.)

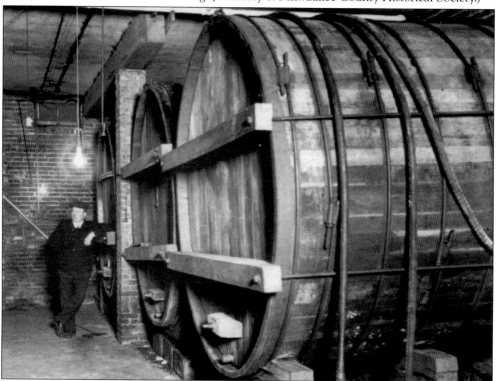

This complex of cream city brick buildings at 2625 South Greeley Street was constructed in 1898. Over the years it was Western Hardware, Milwaukee Patent Leather Company and Greenbaum Tannery. In 2001, some of the buildings were rehabbed into studios for artists and it was renamed the "Hide House" in reference to its days as a tannery. In 2009, the non-historic northern end was demolished and replaced with low-cost housing units. (Courtesy of the author.)

Frank Klement came to Milwaukee in 1910 at age 19 from Czechoslovakia, where he had been an apprentice sausage maker. He worked for Milwaukee Sausage Company at 1334 West National Avenue. In 1956, he purchased Badger Sausage Company (seen here in 1928) at 207 East Lincoln Avenue and changed the name to Klement's Sausage Company. In 1989, a distribution plant opened at 2650 South Chase Avenue.

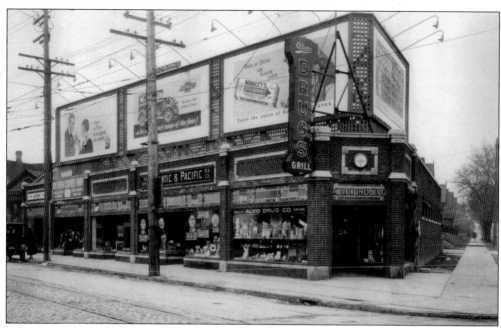

Bay View's Meredith Brothers constructed this red brick building at 2737 South Kinnickinnic Avenue in 1927. It has always been a pharmacy except for Bella's Fat Cat restaurant from 2005 until 2010. The original pharmacy was Alvo Drugs, which was purchased by Jerome House in 1937. Over the years, it was Aiello's Pharmacy and Gull Pharmacy. In 1949, House moved his House Pharmacy to the first floor of Odd Fellows Hall (below) at 822–826 East Potter Avenue. When that building was razed in 1961, the pharmacy was across the street at 2633 South Kinnickinnic Avenue until he retired in 1977. Odd Fellows Hall was owned by the Milwaukee Iron Company until early 1883, when the Odd Fellows acquired the wooden office building and moved it across the ice of Deer Creek Pond. The community used the hall for many activities.

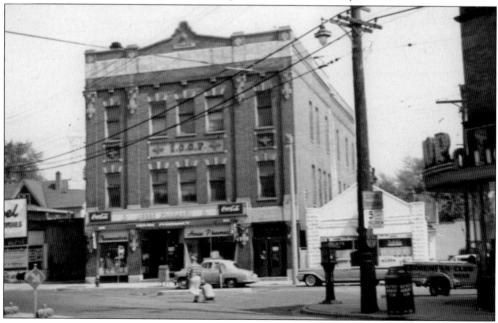

This advertisement from 1930 includes a sketch of the Neoclassical Revival–style Mechanics National Bank built in 1925 by the Meredith Brothers at 2685–2687 South Kinnickinnic Avenue. The name was changed to the Bay View National Bank and then to the First Wisconsin National Bank, which moved to 4001 South Howell Avenue in 1967. Today, the building is the home of Joyce Parker Productions, which owns the building across the street at 2680 South Kinnickinnic. Some of the businesses once housed there include Sterling Furniture, Weninger's Bakery, Meurer's Bakery, and Taxey's Department Store, whose advertisement is shown below.

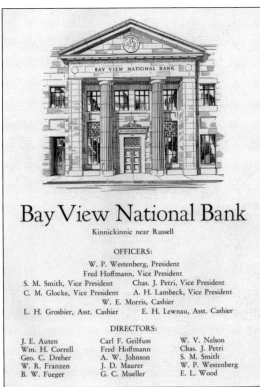

Bay View National Bank

Kinnickinnic near Russell

OFFICERS:

W. P. Westenberg, President
Fred Hoffmann, Vice President
S. M. Smith, Vice President Chas. J. Petri, Vice President
C. M. Glocke, Vice President A. H. Lambeck, Vice President
W. E. Morris, Cashier
L. H. Grosbier, Asst. Cashier E. H. Lewnau, Asst. Cashier

DIRECTORS:

J. E. Auten	Carl F. Geilfuss	W. V. Nelson
Wm. H. Correll	Fred Hoffmann	Chas. J. Petri
Geo. C. Dreher	A. W. Johnson	S. M. Smith
W. R. Franzen	J. D. Maurer	W. P. Westenberg
B. W. Fueger	G. C. Mueller	E. L. Wood

You'll be enthusiastic! about Bobolinks, too.

Bobolink
Pure Silk Hosiery
GUARANTEED!

They're made of pure silk to give them strength. The tight fitting ankle and three seamed back make a smart appearance. Wear Bobolink with the assurance of complete satisfaction or your money back without conversation.

Bobolink

$1.25 a pair

It's easy to get the right shade, with all these colors to choose from—

RACQUET
PEACH
ATMOSPHERE
OOZE
BLACK
WHITE
LOG CABIN
TANBARK
GUNMETAL

FASTEST GROWING STORE.
TAXEYS DEPARTMENT STORE
1296-1300 Kinnickinnic Ave.
Hanover 2820

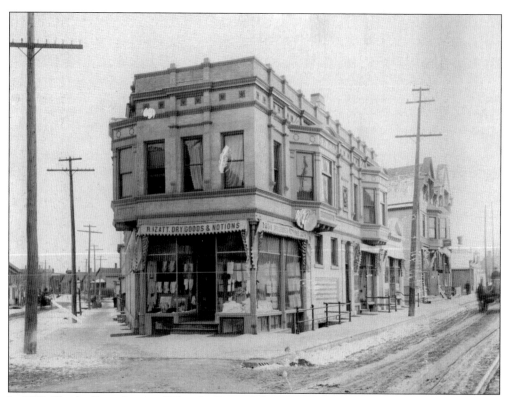

In 1897, Charles Daumling paid Elias Stollenwerk $7,000 to construct this Colonial Revival–style building at 2640 South Kinnickinnic Avenue, according to the plans of Walter Holbrook. The building has been home to Schneider Drugs, Stop & Shop liquor store and is currently the Hi Fi Café. The building across Potter Avenue at 2632 South Kinnickinnic Avenue (below) was built in 1898. Over the years, it was Potter Pharmacy (1921), Bay View Cleaners & Tailors (1931), Bay View Beer Boys Inn (1945), and Siegel Liquor on KK (1949–present).

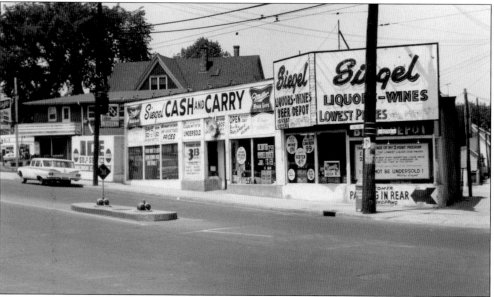

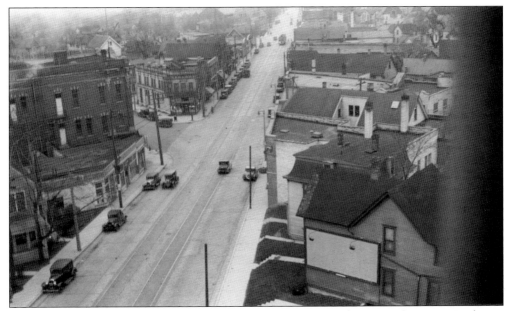

This is the intersection of Kinnickinnic and Potter in 1933 from the tower of St. Lucas Lutheran Church. At left is today's Siegel Liquor and behind Siegel's the three-story brick building is the old Odd Fellows Hall. Across Potter Avenue is today's Hi Fi Café.

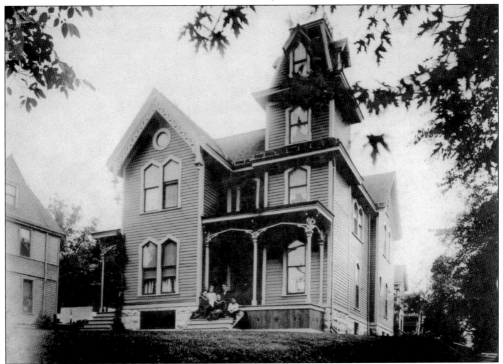

Theobald Otjen's Victorian Gothic home doubled as the offices for his law firm of Otjen and Otjen (page 34). This elegant home at 2501 South Kinnickinnic Avenue was razed in 1962 and replaced by two apartment buildings. Otjen Street was named for the Otjen brothers. (Courtesy of Milwaukee County Historical Society.)

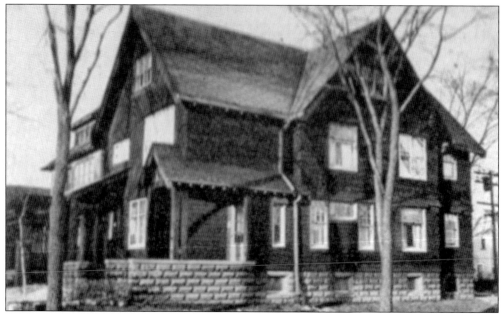

Paul Gauer (1881–1961) was secretary to Milwaukee mayor Daniel Hoan from 1916 to 1920 and was Bay View's alderman from 1920 until 1936. Like Hoan, Gauer was a Socialist. Gauer worked for the betterment of Bay View and was responsible for all Lake Township acquisitions that expanded the borders of Milwaukee and the Bay View community. Gauer's home was built in 1900 at 2476–2478 South Burrell Street.

In 1956, Gauer published *The Gauer Story, a Chronicle of Bay View*, a memoir of the Gauer family and a history of Bay View. Real estate developer Henry Otjen named Gauer Circle in Bay View. When the Gauers celebrated their 50th wedding anniversary in 1955 the celebration included, from left to right, Judge Steinle, Paul Gauer, Mabel Gauer, former Milwaukee mayor Daniel Hoan, and Milwaukee mayor Frank Zeidler.

Jacob Niemann founded the original Niemann Funeral Home in 1896 at 2375 South Kinnickinnic Avenue. At that time, funerals were conducted from people's homes, but gradually there was a trend toward using funeral parlors. Niemann's current chapel, built in 1924 at 2486 South Kinnickinnic Avenue, was the first modern funeral home in Milwaukee. Today, it is the Niemann-Suminski Funeral Home. The home in the photograph below was built in 1889 at 2444 South Woodward. It was purchased by Niemann's and demolished in the 1960s for construction of a parking lot. The home was owned by August Carl Scheunemann (1862–1947) and his wife, Bertha (Timm) Scheunemann (1872–1956); both came from Pommerin, Germany. August built houses and also worked for the railroad. The American flag in the photograph was proudly displayed for every patriotic observance. (Courtesy of Janie Scheunemann.)

J. W. NIEMANN SONS, Inc.

Funeral Home

SHeridan 4-5156

2486 South Kinnickinnic Avenue

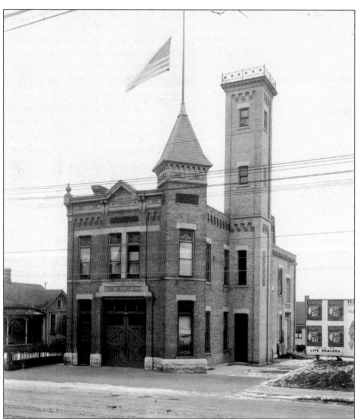

This is the old Engine Company 11 of the Milwaukee Fire Department built in 1891 at 2526 South Kinnickinnic Avenue. The land was purchased from John C. Kneisler for $1,750. John was the brother of William Kneisler, owner of Kneisler's White House Tavern (page 120). In 1965, this station was razed and replaced with the modern station that occupies this site today. (Courtesy of Milwaukee Fire Department Historical Society.)

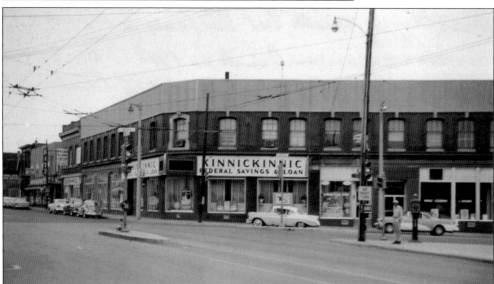

This Neoclassical building was constructed in 1907 at 2301–2307 South Kinnickinnic Avenue and contained numerous stores and offices including the German-American Bank. It is remembered as the home of Kinnickinnic Federal Savings and Loan, which became Maritime Savings Bank. When Maritime left, Alterra Coffee Roasters purchased the building. This building was demolished, and plans are to construct a 13,000-square-foot café and bakery that will open July 2012.

Nothing is known about where this photograph was taken. Pictured in the late 1800s is Bay View postman Anton Olson.

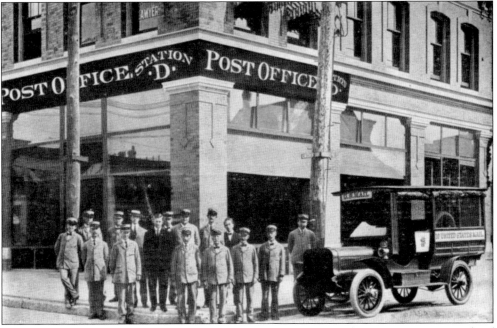

Bay View's post office has been in many locations over the years. These postmen are outside of the post office on the southeast corner of Lincoln and Howell in the German-American Bank building in 1915 (page 92).

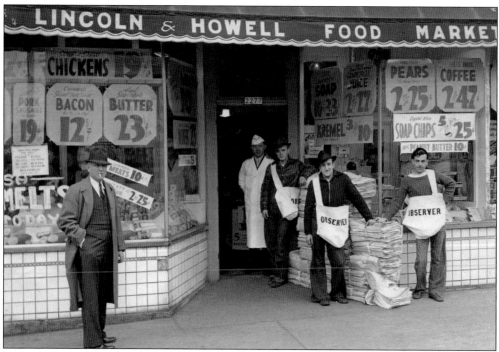

Erwin Zillman (1888–1971) was Bay View's Alderman from 1948 to 1964, when he retired at age 75. He was active in the Bay View Businessmen's Association, Kiwanis Club, and Southside Advancement Association and was editor/publisher of the *Bay View Observer* from 1934 to 1958. In the image above, he is distributing the *Bay View Observer* to the old Hub Foods at 2273 South Howell Avenue. Zillman was nicknamed "Mr. Bay View," and his history of Bay View, titled *So You Will Know*, is mainly from articles that appeared in the *Bay View Observer*. Zillman Park was named for him in 1978; it is the triangle bounded by Kinnickinnic Avenue, Archer Avenue, and Ward Street. Zillman and his wife, Estella (below), lived at 3328 South New York Avenue, where the house still stands.

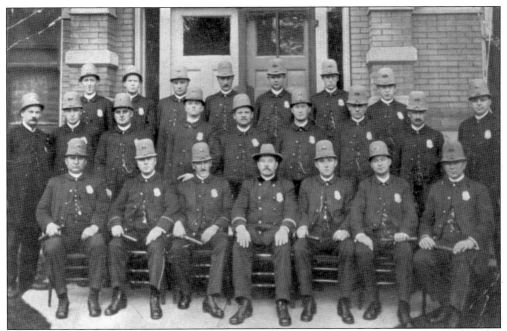

Bay View's police station was located at 908–918 South Allis Street from 1904 until 1953, when the new Second District Station opened at 245 West Lincoln Avenue. The old station was razed in 1959, and the land was converted to a tot lot. Members of Bay View's police force are pictured outside of the old station in 1915.

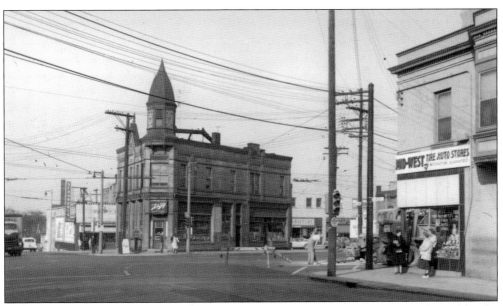

The Five Points area in northern Bay View is an important commercial district formed by the intersection of Kinnickinnic, Howell, and Lincoln. The Triangle Tavern was built on the triangle formed by the intersection of those three streets. The building also housed the Economy Cigar Store. The building was razed in 1959 and replaced with a shelter for people waiting for the bus.

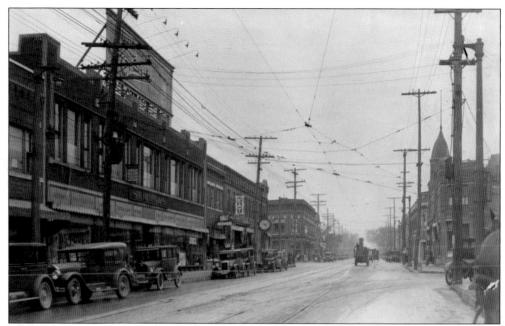

Both of these photographs were taken in the 1920s in the Five Points area from the intersection of Kinnickinnic Avenue and Howell Avenue just north of Lincoln Avenue. The above photograph is looking south along Kinnickinnic Avenue. At left is Strnad's Department Store (later Woolworth's, Salvation Army, and Schwartz Books). At right is the tower of the old Triangle Tavern on the northwest corner of Lincoln and Kinnickinnic. The photograph below is looking south on Howell Avenue. At left is the west side of the Triangle Tavern, which from this perspective is on the northeast corner of Lincoln and Howell. Directly across Lincoln Avenue from the Triangle Tavern is the German-American Bank building (page 92) on the southeast corner of Lincoln and Howell. The tower of St. Augustine Catholic Church (page 39) is visible in the distance on the east side of Howell.

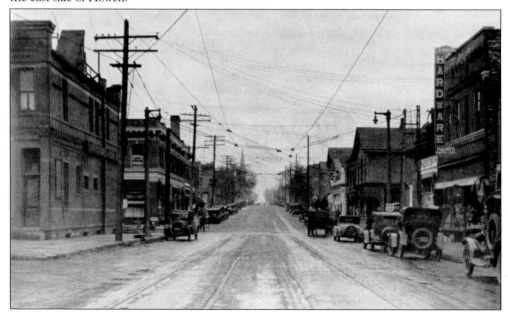

Today, the intersection of Howell Avenue and Oklahoma Avenue is one of Bay View's busiest in contrast to this 1924 photograph. This view is from Oklahoma Avenue, looking south on Howell Avenue. The building on the right (southwest corner) housed Heinz Diehl's Barber Shop and Grafenstein's tavern and bowling alley. It was razed in 1962 and a Super America gas station was constructed, which today is a Speedway gas station.

This image from 1915 is from Chase Avenue, looking east on Oklahoma Avenue toward Howell Avenue.

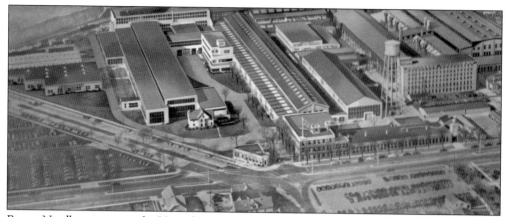

Bruno Nordberg came to the United States from Finland in 1879. He worked as a draftsman for the E.P. Allis Company before founding Nordberg Manufacturing in 1886 in Walker's Point. In 1900, the company, whose specialty was mining equipment, moved to 3079 South Chase Avenue. In the 1970s a merger with Rex Chain Belt formed Rexnord. When the plant closed in 2004, South Milwaukee's Bucyrus International purchased it. (Courtesy of Greg Wernisch.)

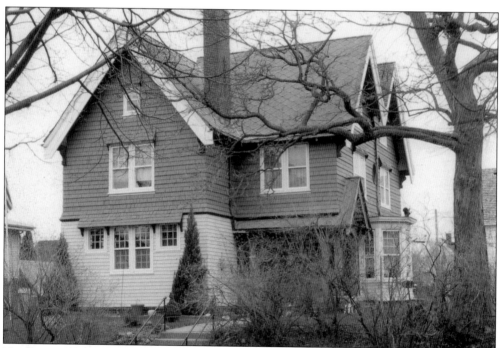

Nordberg and his wife, Helena, built this house in 1902 at 2940 South Logan Avenue. It overlooks Humboldt Park from a hill on the northeast corner of Logan and Idaho. The north half of the property was sold in 1964, and the home at 2932 South Logan Avenue was built. The Nordberg carriage house is part of that property and is visible from the alley. (Courtesy of the author.)

This view from 1930 gives the appearance of being out in the country even though it is looking south on Third Street from Holt Avenue. The north side of Holt Avenue between Chase Avenue and Third Street is now a strip mall, and the south side is residential. (Courtesy of the author.)

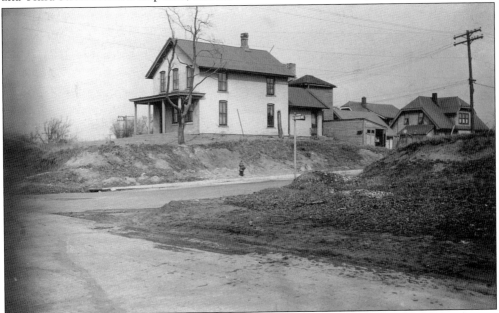

A short distance east of the location featured in the top photograph is the Quail farmhouse, which still stands at 3453 South Chase Avenue on the northeast corner of Chase and Morgan. This photograph is from 1932.

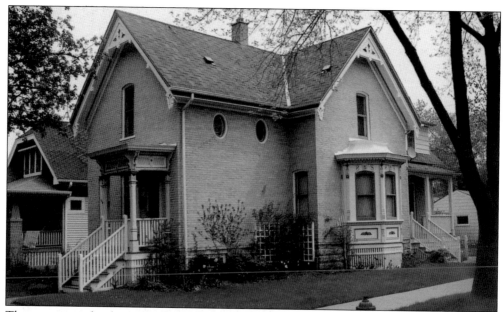

This cream city brick Gothic Revival home is on the northeast corner of Herman and Euclid at 3174 South Herman Street. Note the well-preserved wood trim and detail of the porch. This was the home of contractor Henry J. Riesen. Some people give the date of construction as early as 1875. (Courtesy of the author.)

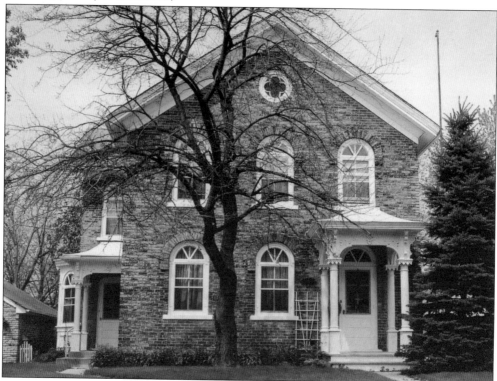

The well-preserved brick Gombar farmhouse at 3273 South Clement Avenue was built in 1877. It is only two blocks from the Riesen home (above).

Architect Peter Brust (1869–1946) was an apprentice for the architectural firm of Ferry & Clas where he worked with Richard Phillip; in 1906, they formed the firm of Brust & Phillip. Their commissions include Columbia Hospital, Gallun mansion (3000 East Newberry), American Club in Kohler, Wisconsin, and churches such as St. Rita (West Allis), St. Florian (West Milwaukee), St. Joseph's Convent Chapel (Layton Boulevard) and St. Augustine (page 39). Peter's father, Christian, who built the cream city brick farmhouse (above) at 3406 South Indiana Avenue in 1909, named Brust Street in Bay View. The house has not been altered except for the addition of the porch. Peter's brother Frank built the house at 3375 South Illinois Avenue (below) in 1904. Today, it looks similar to when this photograph was taken at the time of construction except for the addition of a wraparound porch. (Courtesy of Anna Passante.)

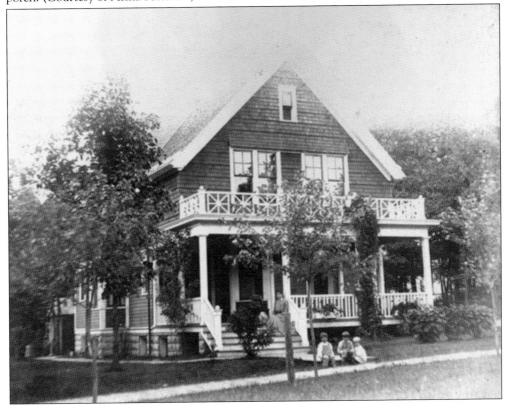

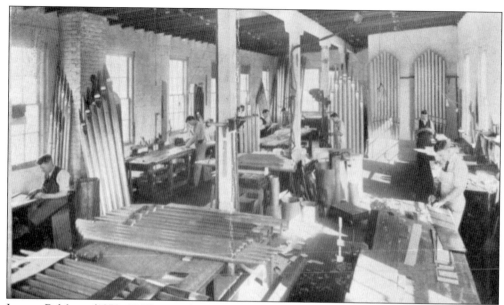

Jerome B. Meyer (1872–1949) came from Germany and learned the organ pipe trade in Ohio and Chicago before coming to Milwaukee in 1910. In 1913, he opened his own business at 2339 South Austin Street to manufacture and repair organ pipes. This undated photograph is the section of the factory where organ pipes are made. Today, Jerome B. Meyer and Sons is still in business at the original location and is headed by the founder's great-grandson Anders.

Frederick Lochemes founded St. Francis State Bank at 3474 South Pennsylvania Avenue in 1923. In 1934, he moved the bank to 3521 South Kinnickinnic Avenue. Over the years, this building, designed by Brust and Phillip, has been home to Beyer Printing, Knights of Pythias, Polish Legion Club, and Ace Homing Pigeon Club. In 2009, Cream City Realty bought the building, which contains a display of Bay View memorabilia.

Charles Nash founded Nash Motors in 1916. Its headquarters was in Kenosha, Wisconsin, but in June 1920, Nash opened an assembly plant in Milwaukee at 3280 South Clement Avenue. This is the first Milwaukee-built Nash coming off the assembly line. In 1954, a merger formed the American Motors Corporation. In 1987, Chrysler purchased American Motors, and the Bay View plant is now the Chrysler Parts Distribution Center.

Fleck Furniture was built in 1890 on the southwest corner of Kinnickinnic Avenue and Becher Street. It was razed in 1962 and condominiums occupy the site today. One block south of Becher Street is Ward Street, named for Milwaukee Iron Company founder Eber Brock Ward.

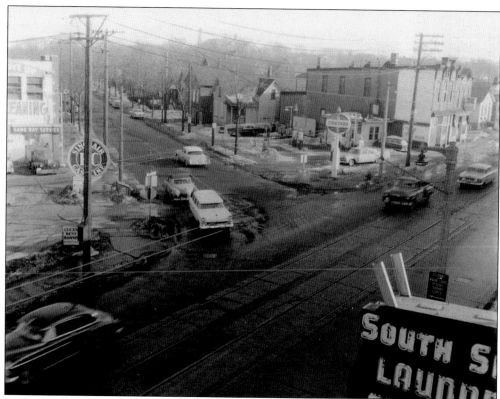

In the late 19th century, downtown became the focus of jobs and shopping, but the route from Bay View to downtown via Kinnickinnic Avenue and South First Street was a long journey. In 1909, the Wisconsin State Legislature authorized a bridge across Milwaukee's harbor to connect Bay View with downtown. Construction began but was halted by violent weather and shoreline erosion. Other attempts over the years never made it past the planning stage due to the Depression and World War II. Following World War II, the increasing popularity of the automobile created massive traffic jams between downtown and the south side. In 1955, the Southeast Traffic Improvement Plan was adopted. These two images show how the two-lane Bay Street (heading into the distance), which connects with Kinnickinnic Avenue, was widened to aid traffic flow through Bay View.

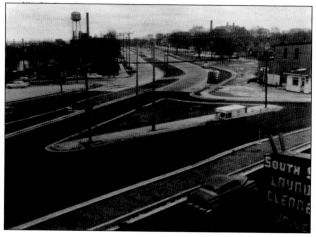

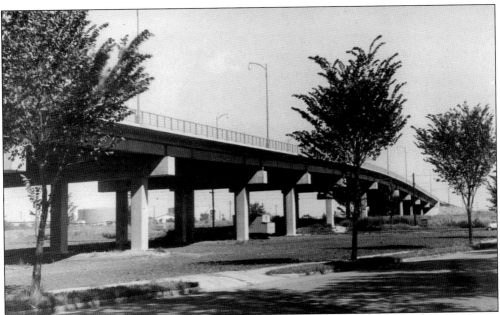

The Southeast Traffic Improvement Plan included this viaduct, built in 1959, which connects Bay Street with Jones Island and would eventually connect with a harbor bridge between Bay View and downtown. The viaduct still stands, but the harbor bridge was never built. Freeways were being planned and Interstate 794 included a harbor bridge between Bay View and downtown. Construction began in 1970, and the bridge was given the name Daniel Webster Hoan Memorial Bridge. Hoan (1881–1961) was Milwaukee's Socialist mayor from 1916 to 1940. In 1975, the $75-million bridge won the "Long Span Bridge Award" from the American Institute of Steel Construction and the American Society of Civil Engineers. The Hoan Bridge (below) spans the harbor and connects Bay View and the south shore with downtown Milwaukee. It opened in 1977, and 43,000 cars use it each day. (Courtesy of the author.)

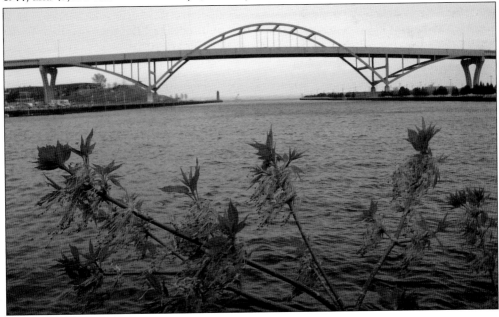

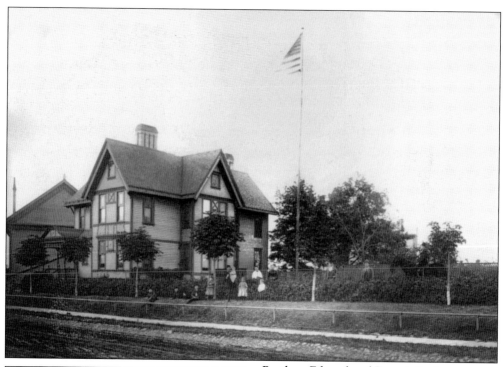

Brothers Edward and Francis Seely came to the United States in the 1870s from Norfolk, England and worked at the steel mill. They owned the adjacent land east of Immaculate Conception Catholic Church. Two Seely homes still stand (1112–1112A East Pryor Avenue and 2657–2659 South Clement Avenue), but this one was razed by Immaculate Conception as part of its 1959 building program. Seeley Street was named for the Seely family, although the name is misspelled.

Residence: 208 Howell Ave.
Phone Hanover 1439

STANLEY F. KADOW
Architect

Member of the Wisconsin Chapter of
A. I. A.
Phone Hanover 3156
451 Mitchell Street
Cor. 2nd Ave. MILWAUKEE

Stanley Kadow (1868–1933) was a low-profile Bay View architect who started as a draftsman for Ferry & Clas. The majority of his work was for residences on the south side with 81 projects in Bay View that were solid and not flashy. He designed some commercial buildings with upper flats such as those at 2501 South Howell Avenue and 2475–2479 South Howell. His home and office still stand at 2466 South Howell Avenue.

John Julian paid $7,000 to construct this Colonial Revival apartment building at 2438–2444 South Kinnickinnic Avenue, designed by Nicholas Dornbach. It was razed in September 2011 and will be replaced with a 70-unit, five-story, mixed-use building. Julian purchased the property from George Edmunds Jr. in 1882, but the property was originally part of the 160-acre farm belonging to Joseph Williams (page 19). (Courtesy of the author.)

In 1894, Herman Taubenheim paid Anton Stollenwerk $6,000 to build this row house at 2553–2565 South Logan Avenue. Row houses are rare in Bay View. The Taubenheim Flats were built on the site of a former wooden roller rink on the west bank of Deer Creek Pond. The rink was open three nights a week and was also used as a hall for concerts, parties, and reunions.

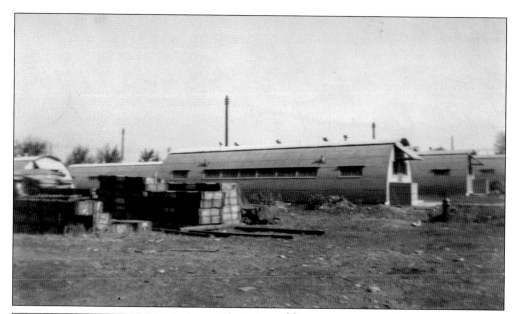

Veterans returning to the United States after World War II created a need for housing. Temporary housing for these veterans and their families quickly sprang up throughout Milwaukee. These Quonset huts were built on the vacant lot along South Bay Street between Lincoln Avenue and Otjen Street. This was originally Deer Creek Pond, but today, it is the Beulah Brinton playground and social center.

The 25-story, 275-foot-high Bay View Terrace at 2500 South Shore Drive, seen here during construction in 1964, is the tallest building on Milwaukee's south side. It was to be Wisconsin's first condominium complex, but the condos did not sell. In 1980, it was finally converted into condos. Bay View's Alderman Erwin Zillman hoped this would be the first of many such projects in Bay View, but his constituents informed him that it would be the last.

Six

RECREATION AND ENTERTAINMENT

Late 19th-century entertainment in Bay View consisted of plays, debates, and musical performances. Parks were private and charged admission until 1890, when Milwaukee established free parks, one of which was Humboldt Park. Two other major parks in Bay View were created along Lake Michigan in the early 20th century when many of Bay View's lakefront homes were threatened by bluff erosion. The homes were either razed or moved to nearby locations and the land was developed into two lakeshore parks that today are part of the Milwaukee County Park system. South Shore Park was carved from part of Elijah Estes's 160-acre farm. Bay View Park, south of Oklahoma Avenue, extends south into St. Francis.

Bay View has several city of Milwaukee playgrounds. Lewis Field on Russell and St. Claire was part of Deer Creek and too soggy for development. It was named for Bay View's Dr. Paul Lewis, who devoted his life to finding a cure for yellow fever. Sijan Field, 2821 South Kinnickinnic Avenue was a farm, brickyard, and garbage dump before being converted into a playground. In 1979, it was named for Air Force captain Lance Sijan of Bay View, who died in Vietnam in 1968. Another former garbage dump is bordered by Fernwood Avenue, Dayfield Avenue, and the Lake Parkway. It was developed into Ellen Park. The Beulah Brinton Playground, part of the Beulah Brinton Center, was built in 1981 on what was Deer Creek Pond before it was drained and filled in as a garbage dump. Finally, Zillman Park, a triangle bounded by Kinnickinnic Avenue, Archer Avenue and Ward Street, was established in 1978 to honor former Alderman Erwin Zillman.

Over the years, Bay View was home to at least five movie theaters. These were the Comique at 2244–2246 South Kinnickinnic Avenue, Union (also known as Rex and Badger) at 2159–2161 South Kinnickinnic Avenue, Mirth at 2651–2653 South Kinnickinnic Avenue, Avenue (also known as Aragon and Pix) at 2311 South Howell Avenue, and the Lake at 2893–2895 South Delaware Avenue. The Avalon Theater at 2473 South Kinnickinnic Avenue is being renovated and scheduled to reopen in the future.

Humboldt Park, originally named South Park, was one of five public parks established in 1890 by the City of Milwaukee. The others were West (Washington), Lake, North (Sherman), and Lincoln (Kosciuszko). In 1900, South Park was named in honor of Baron Freidrich Heinrich Alexander Von Humboldt (1769–1859) a German scientist, naturalist, explorer, and statesman. Land for the western portion of the park was purchased from Jane Wilcox. Land for the eastern section of the park was purchased from the Mann Family who built this mansion (below) in 1895 that still stands at 2931 South Logan Avenue. The Mann family named the streets in this area after states (California, Nevada, Idaho, and Montana), territories (Dakota and Oklahoma), and a Canadian province (Manitoba). Herman Street was named for the family's patriarch, Herman Mann. (Courtesy of the author.)

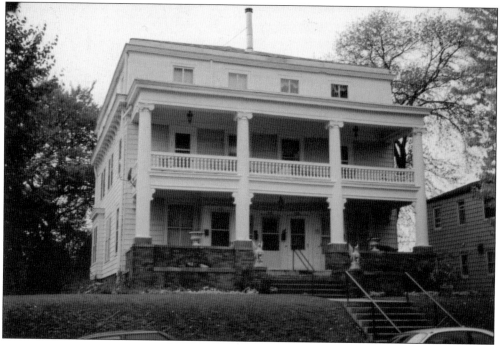

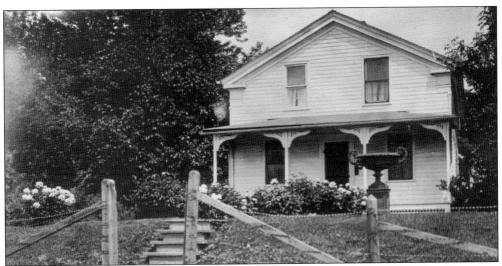

This Greek Revival home was on the land purchased from Jane Wilcox that became the western portion of Humboldt Park. Joel Wilcox, one of Bay View's earliest pioneers, who owned the land east of Alexander Stewart (page 20), built the home. Wilcox's farm was bounded by present day Becher Street, South Bay Street, Lincoln Avenue and Lake Michigan. Wilcox (1808–1873) came from Vesper, New York in 1834 and built a log cabin, which he and his wife, Jane, replaced in 1845 with this Greek Revival–style home. When Joel died, Jane sold the property to the Milwaukee Iron Company and had the home moved to property that she owned at the northeast corner of present day Oklahoma Avenue and Howell Avenue. The home was addressed at 2986 South Howell Avenue and became the residence of the park policeman and later the park superintendent. The last occupant of the home was park superintendent Theodore Gerlach. The home was razed in 1960. Below is the original road through Humboldt Park that ran along the south shore of the lagoon. (Courtesy of David Zach.)

The South (Humboldt) Park lagoon was built in 1893 and enlarged during 1909 and 1910. An island was built that was used for picnics. This pre-1910 image is of the original wooden boathouse on the south shore of the lagoon where rowboats could be rented.

A lily pond was created in 1894 by enlarging a natural depression in the land. Water gardening was popular at the time and a variety of water lilies were introduced. The lily pond was the park's biggest attraction at the time. (Courtesy of David Zach.)

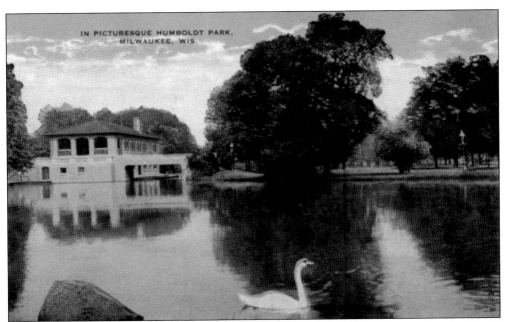

In 1910, a new boathouse was constructed with a concrete footbridge connected to the island. The new boathouse served as a shelter for ice skaters and had an assembly room with refreshment stand until it was razed in the 1960s. (Courtesy of David Zach.)

This wooden open-air pavilion was built in1891. The creek in the foreground was created from the lagoon's overflow and featured waterfalls, rapids, and bridges along its length. The pavilion and creek were removed in 1960, but the curving depression north of the intersection of Taylor Avenue and Oklahoma Avenue is the old trace of that creek.

Humboldt Park expanded in 1922 with the purchase of adjacent land north of Idaho Street that had been a brickyard. This area opened in 1929 and in 1932 a band shell designed by Clas & Clas was constructed as a Works Progress Administration (WPA) project. Used during Fourth of July celebrations and concerts until it was destroyed by fire in 1975, it was rebuilt in 1977 as a chalet using the band shell's base. In this image from c.1937, we see Pauline Goldstein with her two daughters, Nadine (Barthuli) at left and Aurelie (Schubert) at right

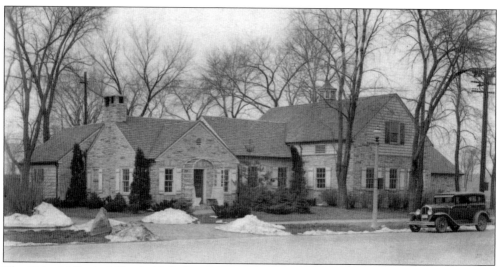

The Colonial Revival Humboldt Park pavilion gives the impression of a New England farm home. It was another WPA project designed by Clas & Clas in 1932. The pavilion is located across the road from the west side of the lagoon.

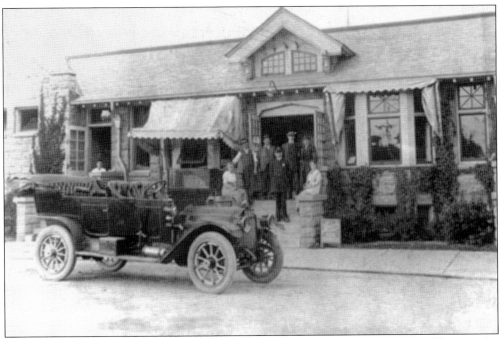

Part of Elijah Estes's farm was developed into South Shore Park starting in 1909. This was the park's original bathhouse, built of rusticated concrete block in 1912 for $11,405. At the time, the park entrance was on Rusk Street, which ended in the park at the bathhouse.

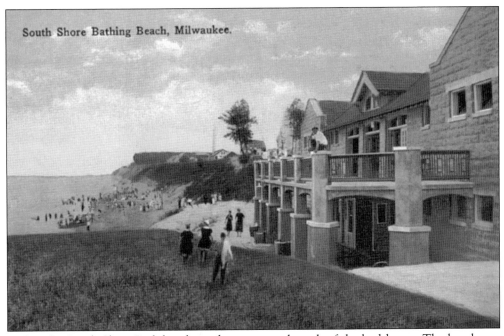

South Shore Bathing Beach, Milwaukee.

Today, the South Shore Park beach is adjacent to and north of the bathhouse. The beach was south of the original bathhouse, as seen in this postcard. (Courtesy of David Zach.)

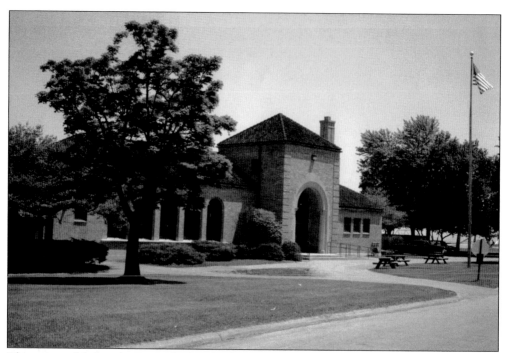

The present Mediterranean-style South Shore Park bathhouse was built in 1934 during the Depression as a WPA project using the plans of architects Clas & Clas. It was given landmark status by Milwaukee County and the Bay View Historical Society in 2009.

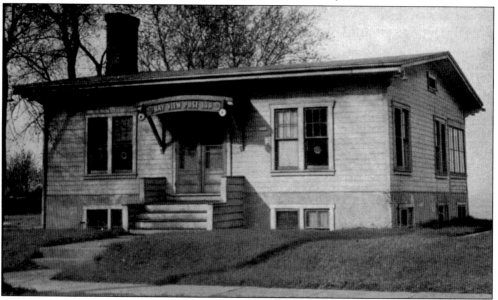

Elizabeth and Ernest Morgan lived on the bluff overlooking Lake Michigan near Russell Avenue, which today is Cupertino Park, named for county supervisor Dan Cupertino. Elizabeth taught at Trowbridge Street School (page 54). The Morgans sold their home to the Steel Mills Yacht Club, which eventually merged with the South Shore Yacht Club. American Legion Post 180 used the building until 1941 when they built a Georgian Revival building at 2860 South Kinnickinnic Avenue.

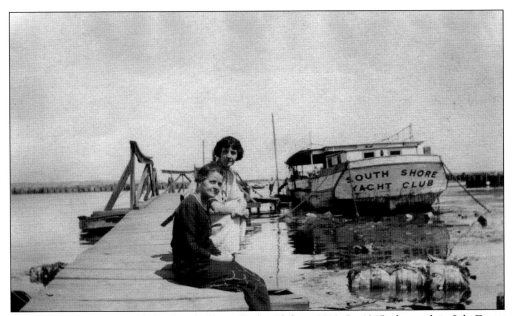

William Lawrie organized the South Shore Yacht Club in 1912. In 1915, the sunken *Lily E* was pulled from Sturgeon Bay, repaired and moored at the foot of East Nock Street as a floating clubhouse. Celia (left) and Elizabeth Williams are sitting on the dock of the bay next to the *Lily E*. By 1921, *Lily E* was beyond repair and scuttled. In 1926, a steel barge replaced her. (Courtesy of Les Johnson.)

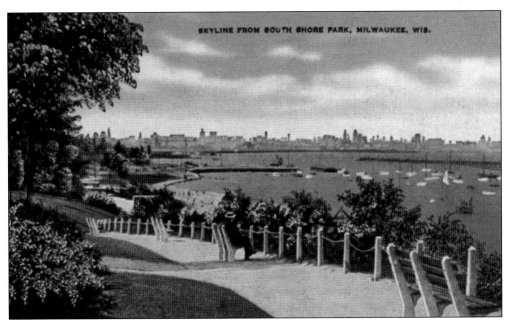

When an October 1929 storm destroyed its barge, the club decided that a permanent clubhouse was vital. The City of Milwaukee extended the Lake Michigan shoreline east from the foot of Nock Street, and the present clubhouse was built on this landfill and dedicated in 1937. The South Shore Yacht Club (Wisconsin's largest) at 2300 East Nock Street is part of Milwaukee's skyline in this postcard image seen from South Shore Park. (Courtesy of David Zach.)

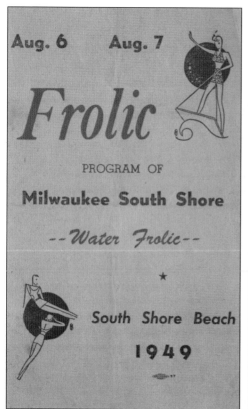

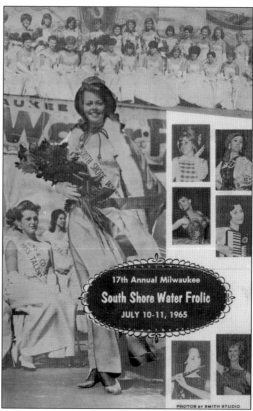

Former Milwaukee mayor Henry Maier referred to the South Shore Water Frolic as "the granddaddy of all city festivals." It was held for the first time in 1949 and every year since, with the exception of 1993. Summerfest, which debuted in 1968, and the ethnic festivals that followed were modeled on the success of the Frolic, including the lakefront location. The Frolic evolved from the South Shore Yacht Club's old Hi-Jinks, a product of the 1930s. As the yacht club grew in size and expanded its mooring facilities, the Frolic's water activities were discontinued and all events moved to dry land. There was a beauty pageant for many years. Participants were identified by their sponsors, such as Miss Jack Langer Pharmacy. The names could get quite comical, such as Miss BiltRite Furniture, Miss Rich's Auto Body, and Miss Rudy's Big Beer Bar. In its heyday in the 1950s and 1960s, the Frolic attracted around 200,000 people. Today, it is known as the South Shore Frolic, and the most popular event is the spectacular fireworks that conclude each day.

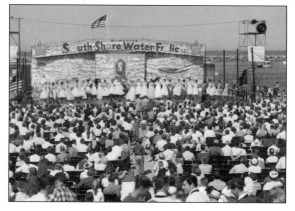

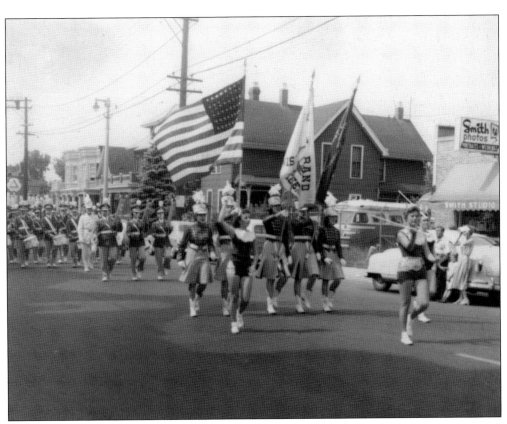

Today, the South Shore Frolic includes a parade. In the past, even when the Frolic had to compete against the Great Circus Parade, Bastille Days and the Greater Milwaukee Open, sometimes all on the same weekend, it still held its own. Today, the three-day event in early July attracts about 70,000 people, which is quite an accomplishment considering that everything is done by volunteers, with funding coming from area businesses.

"Old Smoky" was a steam locomotive known as No. 265, donated by the Milwaukee Road in 1956. The locomotive was on a concrete platform in a green space unofficially known as Bridgeport Park across the street from today's Dom & Phil's De Marinis Restaurant. Despite a cyclone fence and lighting at night, vandalism took its toll. In 1974, Old Smoky was moved to the Illinois Railway Museum in Union, Illinois.

Complimentary — not to be sold

STEAM
LOCOMOTIVE
EXHIBIT
COMMITTEE

PROGRAM OF
DEDICATION

"OLD SMOKY"

Steam Locomotive Exhibit

Sunday, May 12, 1957, 2 P.M.
Harbor Commission Tract
near intersection of East Conway
and South Bay streets

"OLD SMOKY"

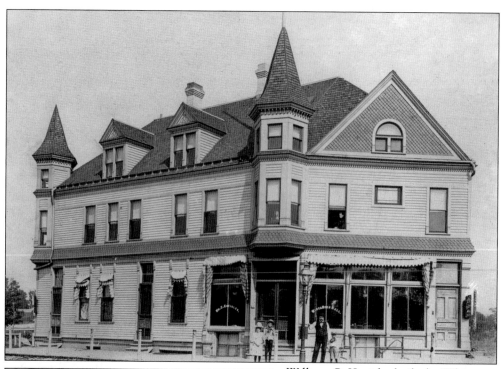

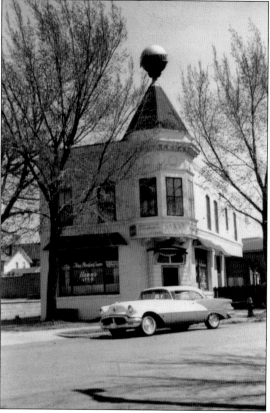

William C. Kneisler built the White House at 2900 South Kinnickinnic Avenue in 1891, and the tavern remained in the family until it was sold in 2006. The name White House comes from the days when the tavern was a popular gathering spot on election night for tallying results. The building, which is said to be haunted, was given landmark status by the Bay View Historical Society in 1991.

The Schlitz Brewery built the Globe Tavern at 2414 South St. Clair Street in 1897 as a tied house for exclusive distribution of its products. The unique feature of this cream city brick building is its turret topped with a belted Schlitz globe. The building is a City of Milwaukee landmark and is on the National Register of Historic Places. Today, it houses the Three Brothers Serbian restaurant seen in this image from 1960.

When the Avalon Theater at 2473 South Kinnickinnic Avenue opened in 1929 as Silliman's Million Dollar Avalon, it was the first theater in Wisconsin to be constructed for sound motion pictures. It is the only remaining atmospheric theater left in Milwaukee. The interiors of atmospheric theaters were constructed to resemble exotic locations. The Avalon's Spanish architecture transported the patron to the Mediterranean region while the use of a cloud machine along with the blue ceiling's tiny lights created the effect of a star-studded sky with passing clouds. After the theater was struck by lightning in the 1940s much of the original exterior was removed during subsequent remodeling. In June 2000, the theater was no longer making a profit and the doors were closed. The theater is under new management and is being renovated with plans for a theater, restaurant, and hotel. It was designated as a City of Milwaukee landmark in 2004.

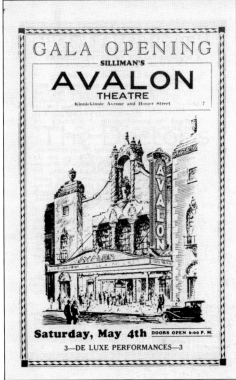

GALA OPENING

SILLIMAN'S

AVALON
THEATRE

Kinnickinnic Avenue and Homer Street

Saturday, May 4th DOORS OPEN 6:00 P. M.

3—DE LUXE PERFORMANCES—3

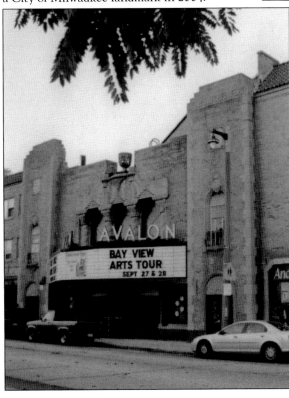

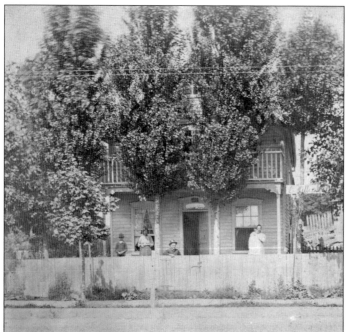

The German immigrant Mueller family lived on one-and-a-half acres north of Lincoln Avenue between Kinnickinnic and Allis at 978 Kinnickinnic Avenue. From left to right in this 1881 photograph are 13-year-old son Henry, mother Susana (1824–1905), father Ludwig (1816–1896), and daughter-in-law Sophia Mueller holding her son Edward. Ludwig was a laborer, carpenter, gunsmith, and watchmaker. The house was razed, and the Strnad Building was constructed in 1911. (Courtesy of Gloria Schneider.)

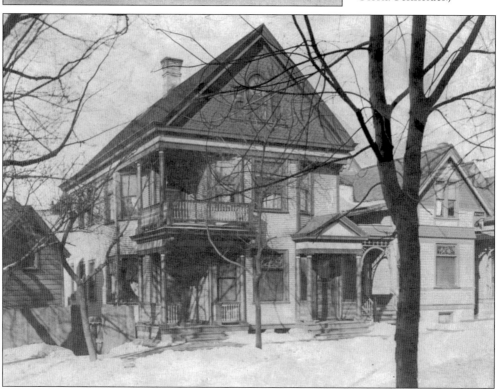

When Henry (1869–1946) grew up, he married Frieda Morgenroth (1878–1941). In 1901, they built this home at 2237–2239 South Allis Street directly in back of the home in the above photograph. Today, the home still looks the same as it did in this 1910 photograph. (Courtesy of Gloria Schneider.)

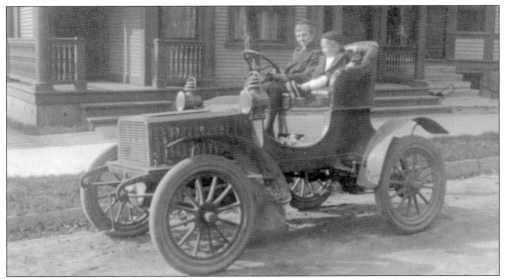

Henry and Frieda Miller's two sons, Clarence and Elmer (left), are sitting in their father's 1904 air-cooled crank model car in front of the family home at 2237–2239 South Allis Street in either 1909 or 1910. In family records, Mueller and Miller are used interchangeably. On Henry's birth and marriage certificates he is listed as Mueller, but the spelling on his death certificate is Miller. (Courtesy of Gloria Schneider.)

Henry Miller spent his entire career at A.O. Smith, starting in 1887 as one of the company's first seven employees and becoming a master mechanical engineer. In 1925, Henry and Frieda Miller built this home at 3030 South Delaware Avenue, where they lived for the remainder of their lives. This 1939 photograph shows them enjoying life's simple pleasures. (Courtesy of Gloria Schneider.)

Winter is a difficult time for many people, but here are some of the ways that Bay Viewites survived past winters. The season from Thanksgiving to New Year's is always filled with festivities and fun. In 1952, Ron and Dorothy Winkler were proud of their real Christmas tree, complete with aluminum tinsel. (Courtesy of the author.)

On a cold winter's night, it was fun to snuggle, as these couples did at a dance for married couples at the Dover Street School social center in 1916.

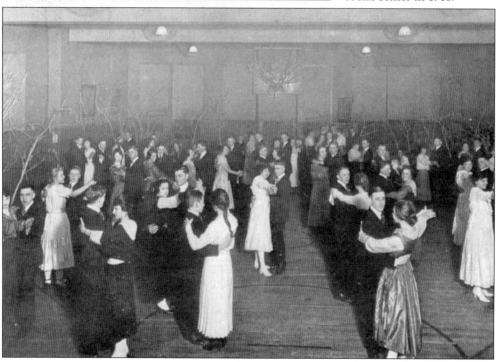

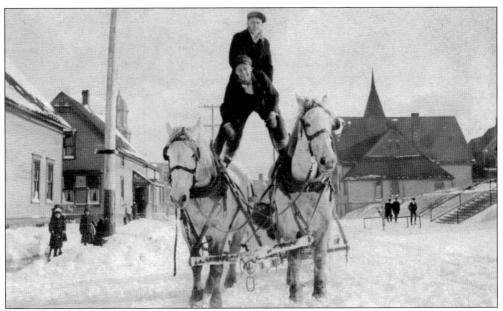

Here is what life in the fast lane once looked like in Bay View. This early 1900s version of hood surfing took place in 1913 on the corner of Russell and Lenox. The steps of the Llewellyn Library are visible at far right. At left, partially hidden by the electrical pole, is the tower of Immaculate Conception Catholic Church. At right is the Bay View Baptist Church.

On January 18, 1947, Milwaukee experienced the storm of the century. People were stranded in streetcars, taverns, bus stations, train stations, and any other place that offered refuge from the wet snow driven by strong winds. When it was over, a total of 18 inches of snow had fallen, much of it blown into drifts up to six feet deep. This image is looking north on Kinnickinnic Avenue from Lenox Street.

Bay View still experiences severe weather. From January 31 until February 2, 2011, Milwaukee and southeastern Wisconsin experienced what, so far, is the storm of this century. Northeast winds with gusts up to 60 miles-per-hour caused the 18–24 inches of snow to accumulate into drifts up to six feet deep. There were also reports of thunder and lightning. Following the storm, Alice Winkler had little room to spare in this alley.

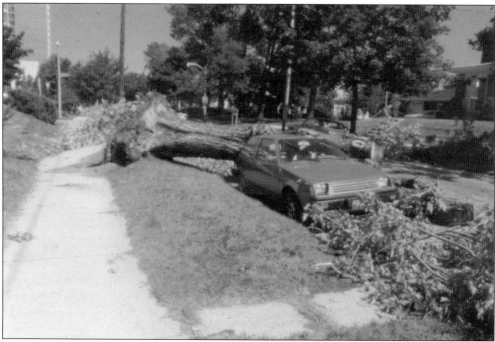

Bay View has experienced tornadoes although none have been very strong. This damage in the 2600 block of South Shore Drive is from the July 10, 1984, tornado that occurred during the early morning hours just after midnight.

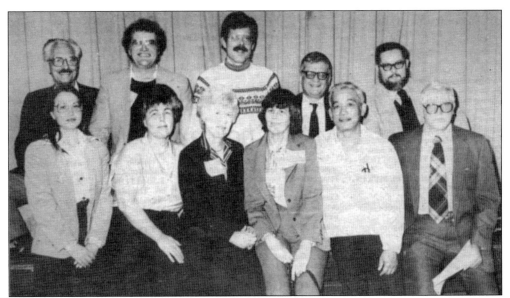

Bay View celebrated its centennial in 1979 with festivities that included a cake and a historical walk through Bay View. An offshoot of the centennial was the establishment of the Bay View Historical Society, which began as a conversation between Bay View neighbors Paul Kohlbeck and Audrey Quinsey. This is the historical society's board of directors in 1980. From left to right are (first row) Cheryl Pendzich, Pat Geyh, Lois Rehberg, Audrey Quinsey, Dick Oshiro, and Ray Bethke; (second row) John Steiner, Paul Kohlbeck, John Gurda, Bob Fennig, and Howard Madaus. Bay View is unique in many ways. Where else but Bay View can you find a street that intersects itself at a right angle? Hiram J. Mabbett was a lumberman who named this street for himself when he platted his land.

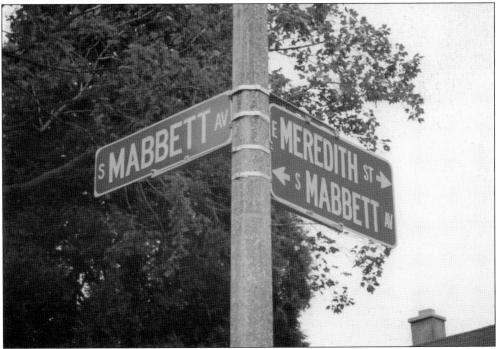

Discover Thousands of Local History Books
Featuring Millions of Vintage Images

Arcadia Publishing, the leading local history publisher in the United States, is committed to making history accessible and meaningful through publishing books that celebrate and preserve the heritage of America's people and places.

Find more books like this at
www.arcadiapublishing.com

Search for your hometown history, your old stomping grounds, and even your favorite sports team.

Consistent with our mission to preserve history on a local level, this book was printed in South Carolina on American-made paper and manufactured entirely in the United States. Products carrying the accredited Forest Stewardship Council (FSC) label are printed on 100 percent FSC-certified paper.

MADE IN THE USA